SEMIPRECIOUS

Salvage

CREATING FOUND OBJECT JEWELRY

Stephanie Lee

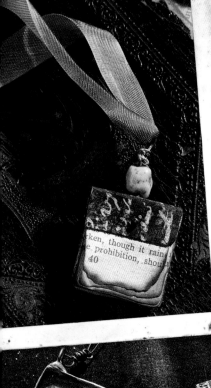

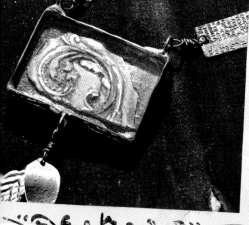

NORTH LIGHT BOOKS
CINCINNATI, OHIO

12 11 10 09 08 5 4 3 2 1

Distributed in Canada by Fraser Direct
100 Armstrong Avenue
Georgetown, ON, Canada L7G 5S4
Tel: (905) 877-4411

Distributed in the U.K. and Europe by David & Charles
Brunel House, Newton Abbot, Devon, TQ12 4PU, England
Tel: (+44) 1626 323200, Fax: (+44) 1626 323319
Email: postmaster@davidandcharles.co.uk

Distributed in Australia by Capricorn Link
P.O. Box 704, S. Windsor, NSW 2756 Australia
Tel: (02) 4577-3555

Library of Congress Cataloging-in-Publication Data

Lee, Stephanie.
 Semiprecious salvage : creating found object jewelry / Stephanie Lee.
 p. cm.
 Includes index.
 ISBN-13: 978-1-60061-019-6 (pbk. : alk. paper)
 1. Jewelry making. 2. Recycling (Waste, etc.) 3. Found objects (Art) I. Title.
 TT212.L435 2008
 745.594'2--dc22
 2007028096

METRIC CONVERSION CHART

to convert	to	multiply by
Inches	Centimeters	2.54
Centimeters	Inches	0.4
Feet	Centimeters	30.5
Centimeters	Feet	0.03
Yards	Meters	0.9
Meters	Yards	1.1
Sq. Inches	Sq. Centimeters	6.45
Sq. Centimeters	Sq. Inches	0.16
Sq. Feet	Sq. Meters	0.09
Sq. Meters	Sq. Feet	10.8
Sq. Yards	Sq. Meters	0.8
Sq. Meters	Sq. Yards	1.2
Pounds	Kilograms	0.45
Kilograms	Pounds	2.2
Ounces	Grams	28.3
Grams	Ounces	0.035

Editor: Tonia Davenport
Designers: Marissa Bowers, Cheryl Mathauer, Kelly O'Dell
Production Coordinator: Greg Nock
Photographers: Al Parrish, Christine Polomsky
Photo Stylist: Jan Nickum

F+W PUBLICATIONS, INC.
www.fwpublications.com

DEDICATION

To my family—as broad as it reaches

ACKNOWLEDGMENTS

To my dad, who let me stay up late at night to finish art show entries when I was in elementary school, who never told me mine was the best (that's a good thing) but always made me feel he thought that.

To my dear, sweet, kind, beautiful mother—your honesty, candor and wit warm the cockles of my heart. You, Mike, Merrie and Evan keep me in stitches.

To Dragonfly, for supporting me in all ways imaginable.

To all my "new" birth family for opening your hearts and doors to me without judgment.

To my dear friends, new and old, tried and true, for your lifesaving humor, inspiring talent, loving candor and for being my mirrors.

To Niki, Chris, Mattie, Travis, Allison and David (Sha-sha-bing-bang, Bob and Mango), I love you all more than I could ever say!

To the genius of my favorite musicians for providing me with engery and momentum.

To Tonia, for all your hard work and support—for being willing to take a chance on me with humor and tolerance for all of my everythings. I will forever be grateful to you.

To Sadie, the wonder dog, my garden and the wind, rain, sun, soil, sea, earth, trees and wildlife— for all you each teach me about patience, gratitude and living in the moment.

To Melissa Rain and Annabelle Sage—for your sweet kisses, twinkling energies, silly antics, admiration and patience. I love you more than you know. My life is so full because of you.

And last but not least, to Vincent, my best friend, my favorite playmate, my traveling companion, my sounding board. You are the measure of a man in whom I have complete trust. Thank you for walking through life quiet and strong and believing in me. I can't wait to see what tomorrow brings for us!

CONTENTS

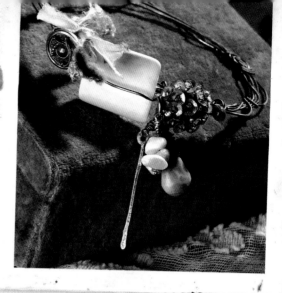

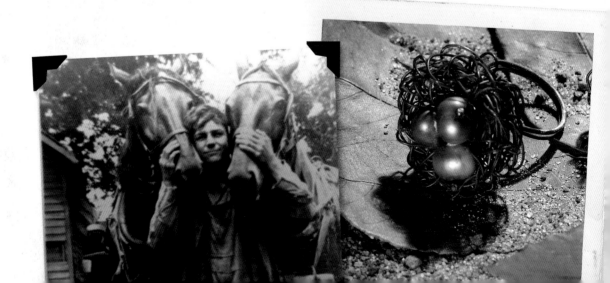

BLAZE BONDING ...70

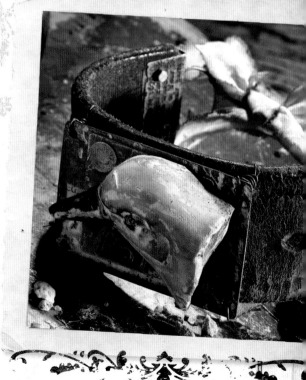

INTRODUCTION

THE PIECES IN THIS BOOK are varied in many ways yet they all share the commonality of repurposing found objects into earthy and semi-refined pieces of jewelry. Unearthed, discovered, salvaged, reclaimed. Interest and intrigue are created in the contrast of old and new—the worn surface of aged metal highlighted against a polished, faceted stone, or luminescent pearls paired with tattered and torn silk. The combination of fresh and faded reflects our lives and never ending journey to presenting an authentic self to the world—rough edges and all.

Rarely do I seek out a fresh and flashy object. Most things I'm attracted to are a bit dirty and worn or discarded. History is worn on the sleeves of such objects—semiprecious in their own right. There is no hiding their vulnerability in a world full of shiny and new, and a connection to the past is maintained when treasures of old are loved for the stories they tell (and the secrets they never will).

In the pages that follow, you will join the party of an expedition from another time. A journal entry of a free-spirited explorer introduces each project and the conceivable unearthing of the found objects used. Join in the adventure of reclaiming the remnants of the past in an artistic, modern representation. Sit quietly for a moment and wonder what history an object might have. Give it a new life and add a chapter to its story. Don your trousers, lace up your boots, bring a shovel and dig in!

GATHERING BASIC TOOLS

No self-respecting "expeditioner" leaves home without the tools necessary for excavating the buried treasures she will unearth. Basic metalworking tools are all that you'll need for repurposing your found objects into functional, beautiful jewelry. Though you will not need every tool for every project, having your camp well stocked will ensure that you are able to alter almost anything, at any given moment.

REPURPOSING KIT

The basic tools in the repurposing kit will allow you to alter found objects and create connections without the use of a torch or soldering iron.

hammer – A small jeweler's hammer is ideal for precision hammering.

tin snips – Choose snips with a smooth, rather than serrated, cutting edge.

wire cutters – Heavier than the cutting portion on a pair of pliers, these make snipping wire a snap.

pliers: needle nose, round nose – These are all available at most craft and all jewelry supply stores.

steel block or anvil – You may purchase this from a jewelry supply source or go to your local steel fabrication shop and rummage through their scrap. Often they will have scrap steel that you can purchase by the pound.

wood block – Any scrap of wood is fine. It will be used to support pieces that you may be drilling through, preventing damage to your work surface.

center punch – A steel punch available at hardware stores, this will be used to create a pilot dent to guide the bit when drilling. While they come in different sizes, I prefer one with a fine tip.

Dremel tool with steel brush attachment – The wire brush will enable you to highlight areas in your jewelry, creating a bit of contrast to the darkened, aged areas.

power drill with 1/16" (2mm) and other smaller-sized bits – Choose a bit made specifically for metal. I always like to have a few on hand for when one gets dull or breaks.

Nova Black Patina (for solder) – Available at stained glass supply stores, this solution is used to blacken and age the various metals used in the projects. There are other blackening agents that will work, such as liver of sulfer. I prefer this because it blackens more quickly and comes ready to use.

metal files – Select a file with a finer tooth for smooth edges. When filing, apply pressure to the metal while pushing the file away from you. Do not file in the opposite direction or you will dull the file.

scissors – You never know when a quick snip or trim will be needed.

clear sealer – I prefer spray-polyurethane in a satin finish, although any sheen will work fine.

tweezers – Use "junk" ones that you plan to use for jewelry-making only.

natural bristle brush – Use one of these to apply patina solution to your pieces.

small glass or plastic bowl – You'll need something for patina solution.

latex gloves – Wear these to protect your hands when applying patina solution to your pieces.

dust mask – It is essential to use one when sanding metal that has had patina solution applied to it.

rag or paper towels – I use these a lot for wiping excess solution off of pieces.

fine grit, wet/dry sandpaper (200–400) – This is used frequently to remove a bit of the darkness that the blackening solution creates and to bring back some of the shine.

metal letter stamps – These are available from jewelery supply stores, catalogs or Harbor Freight and, when used with a hammer, allow you to add text to your objects.

BLAZING PACK

Some of the projects in this book require the use of a propane torch or soldering iron. Though the soldering process may be a little intimidating at first, once you become familiar with these tools you will find them to be indispensable. Be sure to have a heat-resistant work surface and work in a well-ventilated area. (I work out in my drafty garage with inexpensive ceramic tiles laid out on the table I'm working on.) If a project you wish to try out has only a torch in its materials list and not the whole blazing pack, that means you will not need all the other accoutrements for soldering and whatnot, unless listed.

lighter – This is handy for lighting your torch and for burning the edges of paper.

propane torch – You can purchase tip-and-canister sets at your local hardware store. Once you have the screw-on torch tip, you can purchase just the replacement canisters of propane when needed for a few dollars each.

water soluble flux – A paste form works best for the projects in this book but the liquid form will work too, if you have more patience.

flux brush – These inexpensive brushes are sold alongside flux.

lead-free solder – Any type will do but I prefer silver-bearing, lead-free solder manufactured by Canfield.

ceramic tile and concrete brick or paver – The tile will create a larger surface area of protection on your work table and the brick or paver will allow you to elevate some of your projects for ease of torching or soldering.

long needle nose pliers – As a tool to use in soldering, I purchase an inexpensive pair that I don't mind corroding a bit, as it will get flux on it from time to time.

clothespins – I use these as helping hands from time to time to hold objects while I solder.

copper tape, ¹/₂" (-13mm) – Either black-backed or copper-backed. These rolls of tape are available at stained glass supply stores.

adhesive-backed copper sheet – Also available at stained glass supply stores, this sheet is fairly pliable and is handy when you have an area that will require a lot of solder.

soldering iron – It is not necessary to have an iron with a thermostat for the projects in this book, though I do recommend a chisel tip.

sal ammoniac block – One of these is great to clean or re-tin your soldering tip.

damp sponge – You'll appreciate one of these for cooling down something quickly.

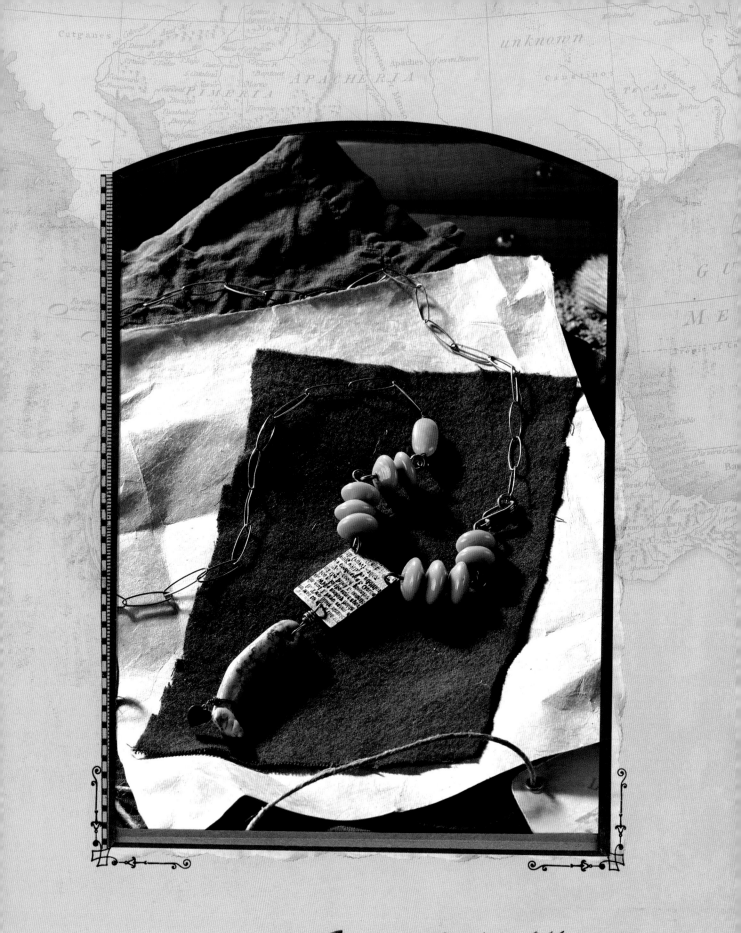

STONE-COLD CONNECTING

ON THIS EXPEDITION, there is little room for unnecessary frivolities. The good thing is that you get to decide what, exactly, defines a frivolity. Daily function must be uncomplicated and simple, and the know-how, to keep it as such, is mapped out in this section, where you will learn to connect and join disparate objects of various material into wearable, beautiful—and practical—works of jewelry art.

The projects in this section will introduce you to the beauty of basic cold connections, enabling you to fabricate a variety of intriguing, layered jewelry pieces, each with a unique history. For the journey ahead, draw on the techniques presented and your own creativity to unearth the beauty of the timeworn objects you have collected. You will find this task to be much easier than imagined.

So, gather your salvaged findings and heed the call of digging for the day. It's time to lay out a few tools and get busy with the repurposing of these little treasures.

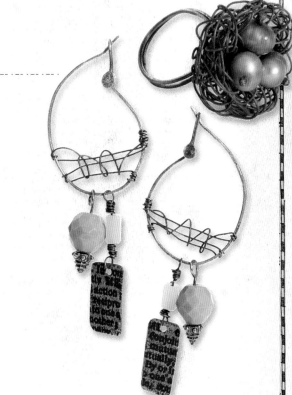

SCROLL BROOCH

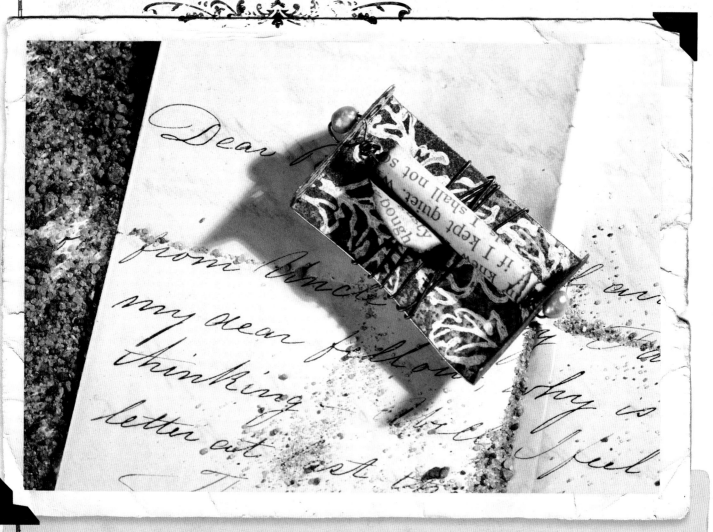

TWO WEEKS INTO THE EXPEDITION, spirits are still high; the morning, crisp and cool. With the sun not yet risen and camp still quiet after yesterday's efforts, I went down to the water to wash my stockings and trousers. With all of the dirt and sweat, one would wonder if my clothing was mine or that of a miner.

On the trail to the water, I was startled by a woman coming around the bend from the other direction. I didn't hear her footsteps approaching and saw that her feet were bare. She wore simple robes of well-worn linen and a single adornment—a small metal box suspended on a chain.

I greeted her quietly, feeling a bit like I had disturbed her solitude in the predawn canopy of leaves. She stopped and greeted me with a slight and quick bow of the head and a smile that held years of story. I boldly asked her about her adornment, wondering what was hidden inside that was so important to be worn performing daily tasks. She reached for the box and opened it, revealing an aged scroll of paper. She told me a story of a love from many years ago—a youthful couple full of adventure and curiosity and . . . a love letter. "How else could I protect this more, than to keep it hovering over my heart?" she asked. Clutching the box, the woman gave a weathered, knowing smile and slowly continued on her way.

EXHIBIT 14

REPURPOSING KIT

white acrylic paint

wax paper

brayer

rubber stamp of choice

scrap piece of aged metal

permanent marker

clear caulk (or other
heavy-duty, metal-to-
metal glue)

pin back

black wire, 24-gauge

book text

lighter or matches

gel medium and
small artists brush

skewer

freshwater pearls

Gives a ri
While n
CROWN
ladies

step **1** Cut out metal piece

Spread out a small amount of white acrylic paint on a piece of waxed paper with
a rubber brayer. Ink up your rubber stamp by rolling the paint-covered brayer onto
the stamp. Stamp onto your aged metal. When it's dry, seal it with clear spray sealer.
Using metal shears, cut a piece from the stamped metal that is approximately 2"× ¾"
(5cm × 19mm). (Note: I just eyeball this.)

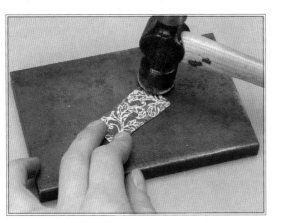

step **2** Hammer flat

On a metal block, hammer the piece nice and flat being sure to hit the edges well.

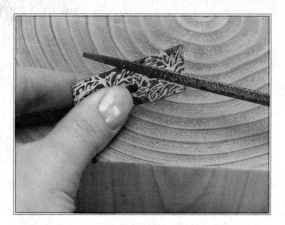

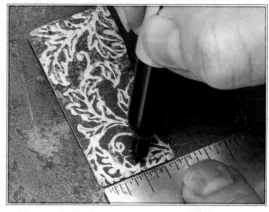

step **3**

File the edges

File off any rough burrs or edges, using a metal file. Be sure to file the sharp corners. First, file all edges with the front of the piece facing you, then turn the piece around and file the edges again from the same direction.

step **4**

Mark holes for drilling

Make two marks, using a permanent marker, on each short end of the metal, ¼" and ½" (6mm and 13mm) from the top with both marks ¹⁄₁₆" (2mm) from the edge.

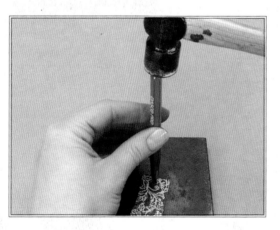

NOTE {to self}

When filing metal, be sure to apply pressure only on the forward stroke. If you apply pressure on the return stroke, you will dull your file quickly.

step **5**

Prepare to drill

Use the center punch to make indentations at your marks, in order to prevent the drill bit from walking when you start drilling.

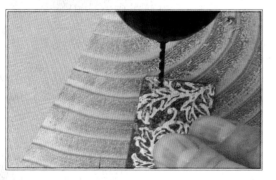

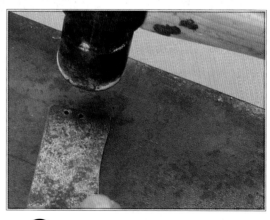

step **6**

Drill holes

Drill a hole at each of the marks.

step **7**

Flatten holes

Turn the piece over and hammer the back on a steel block, over the holes, to flatten any burrs.

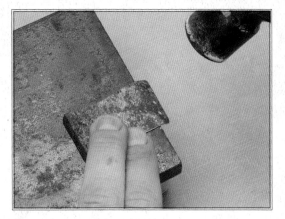

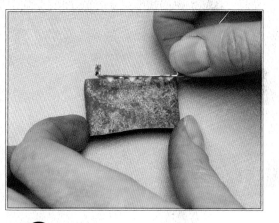

step 8 Create edge fold

Let the piece overhang the metal block about ¼"
(6mm) and hammer it over the edge. For the
second side, get it started with the hammer and
then use pliers to bend it the rest of the way.

step 9 Attach pin back

Use clear caulk (or metal glue) to glue
the pin back to the back of the metal.

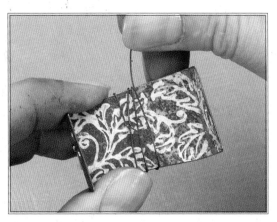

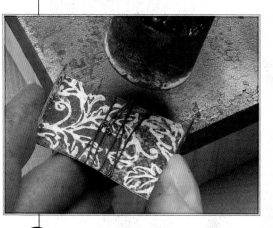

step 10 Wire pin back

Clamp with a clothespin or squeeze clamp and
set aside to cure. When the caulk is set, cut a
length of black wire about 12" (30cm), and wrap
the wire around the center of metal piece
several times.

step 11 Secure the wire

Twist the ends together in the front to
secure, and then flatten the wire a bit
with a hammer. (The ends of the wire
will be hidden.)

step 12 Prepare the paper scroll

Tear a piece of old text to about a 1¼"
x 2" (3cm x 5cm) piece. Carefully burn
the edges of the paper with matches or
a lighter to create an aged effect.

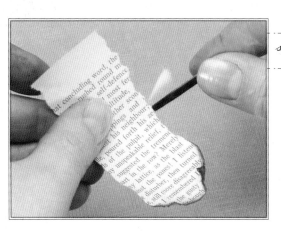

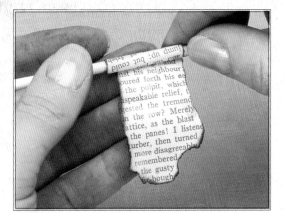

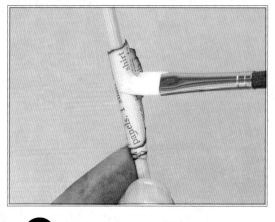

step **13** ## Roll the scroll

Coat one side of the paper with gel medium, using a small brush, leaving about ½" (13mm) at one short end uncoated. While the medium is still wet, start at the end of the paper that is uncoated and roll it up on the skewer. Leave about ⅜" (10mm) unwrapped.

step **14** ## Seal the scroll

Coat the outside of the scroll with additional medium while it's still on the skewer. (Make sure the paper isn't stuck to the skewer, so you can easily remove it when the scroll has dried.)

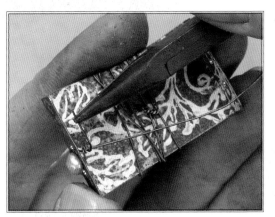

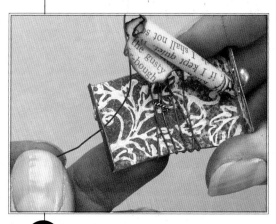

step **15** ## Attach the pearls

Cut a 6" (15cm) length of wire and string one pearl on one end, positioning it about 1½" (4cm) from the end. Fold the wire at the pearl and stick both wire ends through the holes on one end of the metal. Wrap the short end of the wire back around the long end.

step **16** ## Add the scroll

Thread the paper scroll bead onto the wire.

step **17** ## Finish wire wrapping

Thread the wire through one hole on the other end, thread the other pearl on and then thread the wire back through the second hole. Using pliers, carefully wrap the wire end around the wire that the scroll is threaded onto. Snip off any extra wire and tuck in to secure.

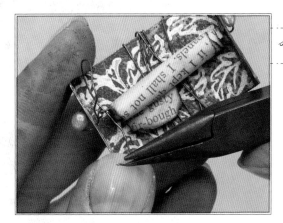

BUTTON PENDANT

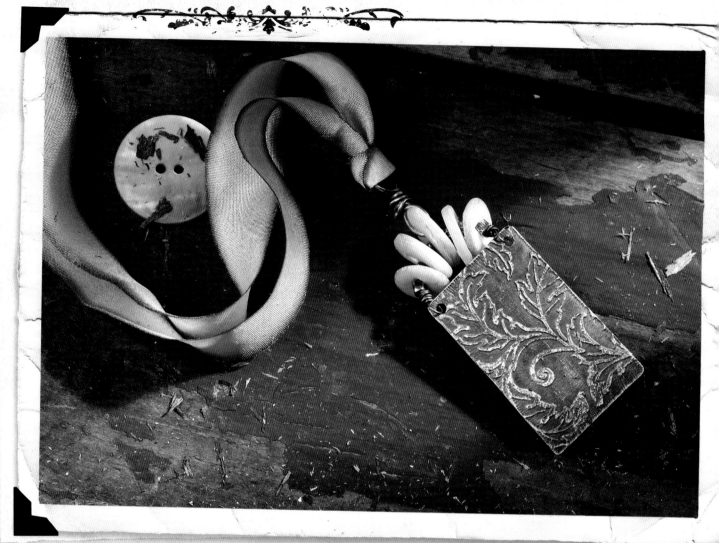

Day 25

IT'S BEEN RAINING FOR DAYS and we've all been cooped up in our tents. Being full of cabin fever I geared up for a romp to the village. I'd heard of a woman who makes goat cheese and I decided I must find her and have a taste. After about an hour of wading through puddles, and mud so rampant it was hard to imagine the ground was dry and parched not a week ago, I arrived at the woman's house. It appeared to be a shanty of a place, with a doorway I had to bow to walk through. I was surprised to see dry floors and a crackling fire inside.

She greeted me with a youthful giggle as her aged hands motioned for me to sit on a low, wooden stool by the fire. I removed my dripping coat and sat as directed. She left the room to fetch the cheese for which I had come. I surveyed the room lit only by the fire, the occasional opening of the door as the woman moved about, and a single small window. In such simple surroundings I was enchanted by strands of old shell buttons hanging in the window in place of a curtain. Hundreds and hundreds of them, stacked one upon another. I found myself mesmerized by their lethargic swaying in the sporadic breeze coming through the open window. The woman reentered the room with a platter of moist, fresh cheese and I snapped out of my hypnotic stare to savor the delicacy she offered—well worth the walk.

Daypack Essentials

↓

REPURPOSING KIT

nickel sheet

rubber stamp of choice

permanent ink, such as
Memories or StazOn
(black or dark color)

masking tape

etchant solution (sold
as PCB Etchant Solution,
Ferric Chloride at Radio
Shack) and small container
for solution

baking soda

sterling silver wire,
18-gauge

two-hole vintage buttons, 5

½" (13mm) dowel

black wire, 24-gauge

small spacer beads

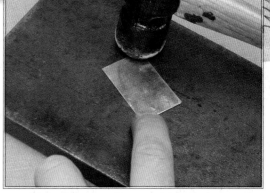

step ① Cut the metal

Cut a piece from the nickel sheet, approximately
1" × 1½" (3cm x 4cm).

step ② Hammer flat

Hammer the piece flat. It will get marked
up, but that adds to the character. (A flat
piece of metal receives a stamp image much
better than one that is slightly uneven.)

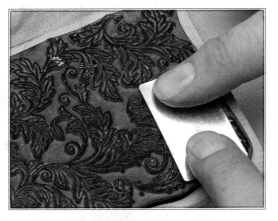

NOTE {to self}

*When sanding metal that has been etched,
wear a mask and work in
a well-ventilated area to avoid
breathing the dust.*

step ③ Stamp pattern for etching

File the edges to remove the burrs and roughness.
Ink up your rubber stamp with a permanent ink
and press the metal onto the stamp to print. Set
aside to dry.

step 4

Prepare metal for etching

When the ink is dry (you can use a heat gun or hair dryer to speed up the process), burnish a piece of masking tape to the back of the metal piece. Be sure to burnish well around the edges to prevent etchant solution from seeping under the tape.

step 5

Etch the metal

Float the piece on the surface of a container of etchant solution, suspending it from the container with the tape.

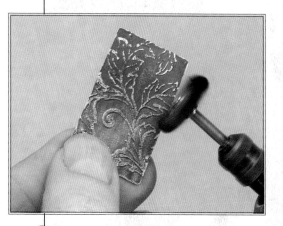

step 6

Neutralize the solution

After a couple of hours, remove the piece and dip it into water. Pour a bit of baking soda over the piece and scrub it lightly to neutralize it. Wash well with soap and water. (See page 29, step 8 for information about disposing of the solution.)

step 7

Highlight the pattern

Apply blackening solution to the metal and let it sit for a minute, then wipe off the excess with a paper towel. Wearing a mask and working in a well-ventilated area, lightly sand the agent off of the etched areas, using sandpaper. To really bring up the shine, polish the piece with a wire brush attachment and the Dremel tool.

step 8

Drill holes for attaching buttons

Mark for two holes, each ⅛" (3mm) in from each corner on one of the short ends. Use the center punch, steel block and hammer to start the holes. Drill at each mark to create the holes. Hammer the holes from the back to remove the burrs.

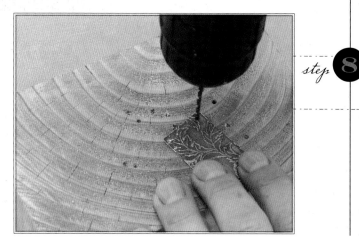

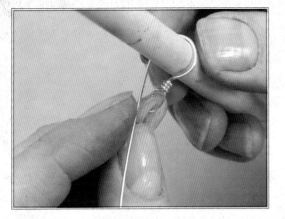

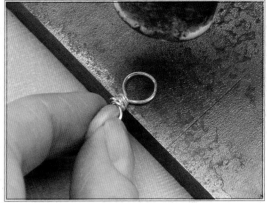

step **9** ## Create the bale

Cut a 4" (10cm) length of sterling wire. Create a loop with round nose pliers at one end of the wire and thread through one of the holes on the largest of the vintage buttons. Wrap the end, then create a larger loop using a dowel.

step **10** ## Finish the bale

Wrap the excess wire around the base of the larger loop to finish. Using a hammer and metal block, lightly flatten the larger loop.

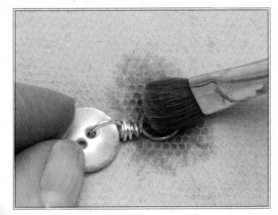

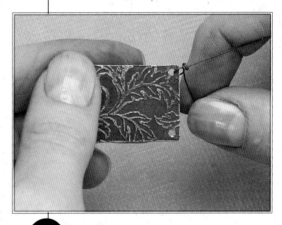

step **11** ## Age the bale

Brush on some blackening agent. Once it has blackened as much as you want, wipe with a paper towel. Highlight areas of the wire by lightly sanding it.

step **12** ## Attach the buttons

Cut a 6" (15cm) length of black wire and create a loop about 2" (5cm) from one end. Thread on the metal piece in one corner and wrap the end of the wire around itself.

step **13** ## Finish adding the buttons

Thread on a small spacer bead, then through a hole in one button, then a spacer bead, then a button, then a spacer and then the center button that you created the wire wrap on. Proceed with another spacer, another button, another spacer, another button, a final spacer and then thread the wire through the hole in the other corner of the metal and wrap the end like you did with the first corner. Your new pendant can now be hung on your favorite chain or ribbon.

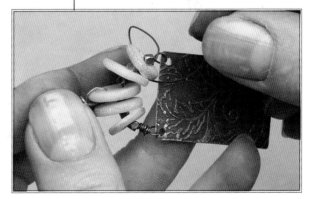

BUNDLED-SILK PIN

Day 32

THE RAINS FINALLY LET UP and we moved on to the next dig site. We arrived eager to get on with our work, which had been hindered by the weather. The pack mules even seemed anxious to get moving again, despite their heavy workload—bedding, tents, clothing, tools, and even some of the comforts of home, like china teacups for the most finicky in the group. (I scoffed at their insistence for such luxuries.)

This evening we gathered for tea and repartee after a long day of digging. I was handed a fresh cup of tea along with a slice of sweet bread on a flowered china plate and a bundled silk napkin nestled in an engraved silver ring. (What opulence for such an expedition!) As I clutched the bundle, freeing it from its ring and using the soft silk to dab stray crumbs from my mouth, I began to appreciate the luxury, in light of our accommodations. I suppose we all need a little something of comfort to remind us to nurture ourselves even on such an arduous journey. As time and the elements chisel away at our patience, such luxuries seem to be a much-needed connection to home—and sanity.

↓

REPURPOSING KIT

masking tape

small metal frame charm

two-part epoxy resin
(Envirotex)

snippet of book text

torch or lighter

etched nickel piece, 2"
(5cm) square (see page 19
for etching instructions)

dowel or carpenter's pencil

silk scraps

black wire, 24-gauge

pin back

permanent marker

micro brass bolts
(available at hobby shops)

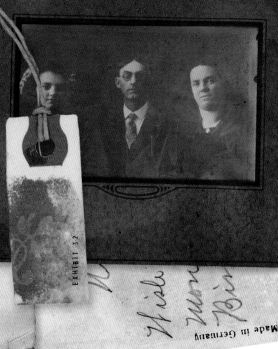

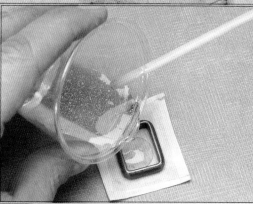

 ①

Fill the frame with resin

Burnish a piece of masking tape to one side of the metal frame charm. With a
clothespin or paintbrush handle, burnish really well around the edges of the frame
to make sure no resin will seep out when filling. Mix equal parts of two-part epoxy
resin in a disposable cup per the manufacturer's instructions. Stir thoroughly and
slowly to avoid too many bubbles. Fill the frame about halfway.

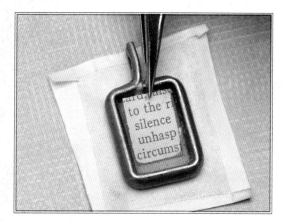

step ②

Add the text

Use tweezers to place the snippet of text onto the surface of the resin.

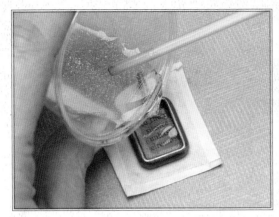

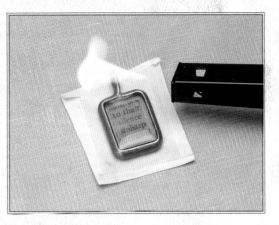

step ③ Finish filling the frame

Pouring the resin slowly, fill the frame up the rest of the way.

step ④ Burn out the bubbles

Move a lighter over the top of the resin to pop the bubbles. Set the frame aside to cure. Check the frame every 10–15 minutes for the first hour or so for new bubbles. Burn them out the same way, if needed.

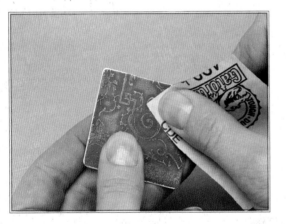

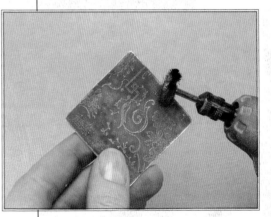

step ⑤ Sand the etched nickel

Etch the nickel piece (see page 19). Hammer, and file it, then sand it with sandpaper to remove the etchant over the raised areas to highlight the pattern.

step ⑥ Polish the metal

Polish the piece with the wire brush and the Dremel tool.

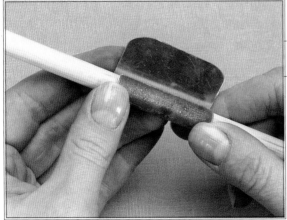

step ⑦ Form the metal

Bend the polished metal piece around something such as a dowel or carpenter's pencil, to fold about a third of it up.

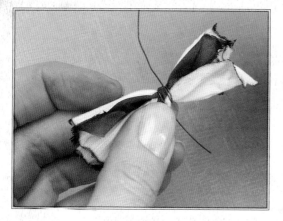

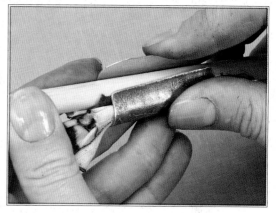

step 8 Tie the silk bundle

Cut a width of silk to be about 1" (3cm) wider than the metal piece, gather it up, then wrap black wire around the center to secure it.

step 9 Close the metal fold

Push the silk wad into the fold of the metal piece. Using the dowel, bend the flat portion of the metal to fold toward the other direction. Overlap the folded ends of the metal about ¼" (6mm) or a little more.

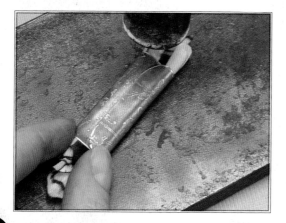

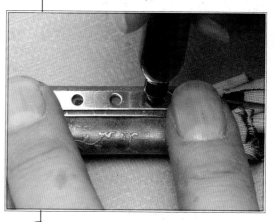

step 10 Flatten the folds

Use a hammer to flatten the piece a bit.

step 11 Mark for drilling

Using the holes on the pin back as a guide, center the pin back over the overlapped edge of the metal, and mark two dots, one on each side of the center.

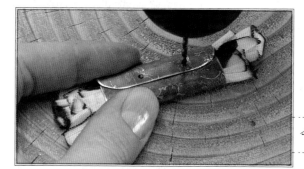

step 12 Drill the holes

Make a mark with a center punch, then drill two holes through the entire piece. Drill slowly to prevent the silk from binding up on your bit. If this happens, slowly back the bit out and start again.

NOTE {to self}

To keep the silk from binding up around the bit, have a friend pull both ends of the bundle tightly while you drill slowly.

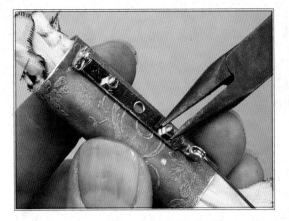

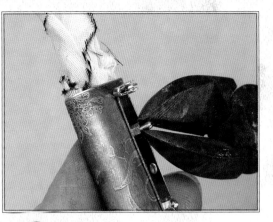

step 13 ### Bolt on pin back

Insert bolts through the holes from the front to the back, and place the pin back over the bolts. Secure the nuts on the back firmly.

step 14 ### Snip the bolts

Snip the excess bolt length off, using wire cutters. File the ends of the bolts to remove the burrs.

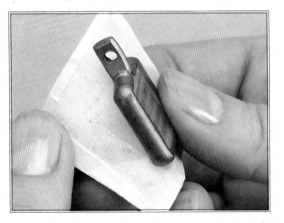

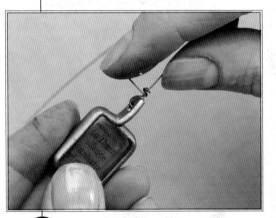

step 15 ### Untape resin-filled frame

After the resin has cured, remove the masking tape from the back of the filled frame.

step 16 ### Attach wire loop to frame

Cut a 9" (23cm) length of black wire and create a loop at one end. Thread on the bezel charm and wrap the excess wire around the base of the loop.

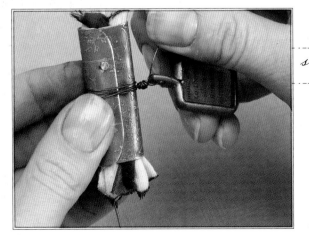

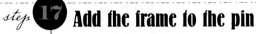

step 17 ### Add the frame to the pin

With the pin back open, wrap the long end of the wire around the center of the metal/silk piece several times. Wrap the small remainder of the wire back around the original wire wrapping and above the hole in the frame charm.

EVIDENCE NECKLACE

Day 35

THE DIG WAS VERY PRODUCTIVE TODAY. We've unearthed many remnants of past lives. Shards of this and that but nothing complete, as is typically expected. One find struck me as most interesting—a lonely arm from a porcelain doll. Inconsistent with the period of our usual findings, it caused me to wonder about its origin. It lay with a strand of blue glass beads that were weighty and solid. Too solid to have been buried for as long as the other finds we had unearthed. Where did these items come from? Who were their owners and why were they left here? We dig to find answers and often are left with more questions than we initially carried.

We sat in the shade of a lone tree to rest for lunch. I listened to my colleagues speculate on the origin of these peculiar finds and surrender to the fact that we may never know. Still, I was reminded that while much of the finds we unearth are full of stories of adults going about the business of daily life and survival, the laughter of little children once echoed through these hills as well.

↓

REPURPOSING KIT

nickel sheet

laser/photocopy of
reverse text

cotton swab

acetone polish remover
(straight acetone is
too strong)

iron

masking tape

etchant solution
and small container

brass heart charm

metal letter stamps

black acrylic
paint and brush

paper towel

brass wire, 20-gauge

sterling silver wire,
18-gauge

doll hand/arm

blue bead necklace

large accent bead

silver chain, 24" (61cm)

step **1** ## Choose text to etch

Cut a piece of nickel from the sheet that is about 1" (3cm) square. Hammer it and file the
edges, including rounding the corners. Cut a piece from the photocopy that is the same
size as the metal. Note: The text can come from something scanned or from something
you compose yourself, but it should be white text on a black fill. You should use the mirror
option in your program to reverse the direction of the type.

step **2** ## Prepare to etch

Place the copy facedown on the metal and dab it with a cotton swab
dipped in acetone. Dab over the entire surface to saturate the paper.

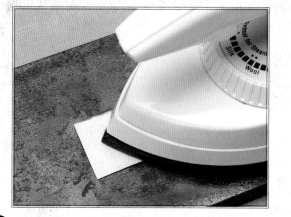

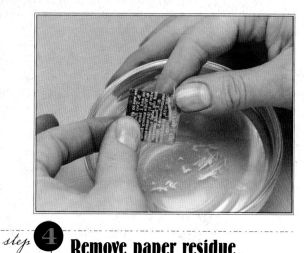

step 3 · Transfer the copy

Apply a hot iron to the piece for several seconds until the acetone is dry from the heat of the iron.

step 4 · Remove paper residue

Dab on additional acetone, then go over it again with the iron. Do this one or two more times. When cool, soak the piece in water and gently rub off the paper. The toner will now act as a resist in the metal etchant solution.

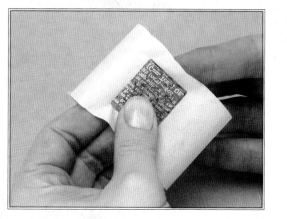

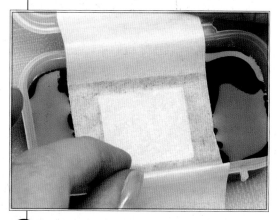

step 5 · Protect the back of the metal

When it's dry, burnish a piece of masking tape to the back of the piece. Burnish the tape around the edges as well to prevent etchant solution from seeping under.

step 6 · Etch nickel piece

Float the piece on the surface of a container of etchant solution, suspending it from the container with the tape.

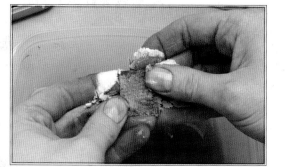

step 7 · Clean etched nickel

After a couple of hours, remove the piece and dip it into water. Pour a bit of baking soda over the piece and scrub lightly to neutralize it.

NOTE {to self}

Sometimes etchant solution can make the edges of the metal sharp again. If it does, just refile them with a metal file.

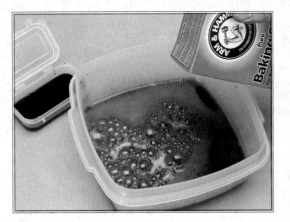

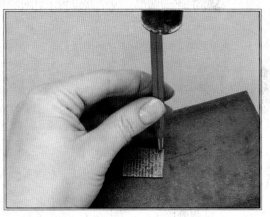

step **8** **Neutralize the etchant**

Before disposing of the etchant solution, add a bit more baking soda to the water, then pour in the solution. When it has quit bubbling, it is neutral and is safe to dump on an old rag in a plastic bag and throw away.

step **9** **Mark holes for drilling**

Using a brush, apply blackening solution to the metal piece and let it sit for a minute. Wipe off the excess then sand it with sandpaper; remember to sand the back as well. Seal the piece with spray sealer. Mark for two holes, each $\frac{1}{8}$" (3mm) in from each corner and one centered $\frac{1}{8}$" (3mm) from the bottom, using a center punch and hammer.

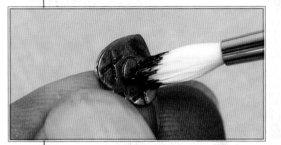

step **10** **Flatten holes**

Drill at each mark to create holes. Hammer the holes from the back to flatten the burrs.

step **11** **Stamp the charm**

Using metal letter stamps, stamp "XOX" onto the heart charm. Brush black acrylic paint over the front of the stamped charm.

step **12** **Hang the charm**

Lightly wipe away the excess paint, using a paper towel, to reveal the blackened letters. Cut a 4" (10cm) length of black wire and create a loop at one end, using round nose pliers. Thread on the charm and then wrap the excess around itself.

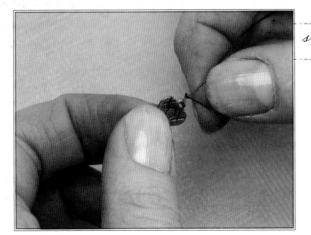

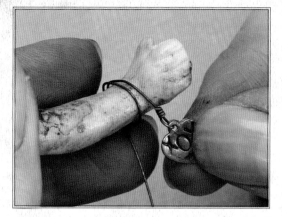

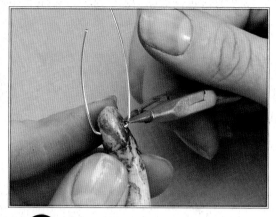

step 13
Attach the charm

Wrap the rest of the wire around the wrist of the doll arm. Secure the end of the wire back around itself just above the charm.

step 14
Add the wire to doll arm

Cut a 4" (10cm) length of sterling wire and thread one end through the hole in the arm. Adjust the wire so that the arm swings freely.

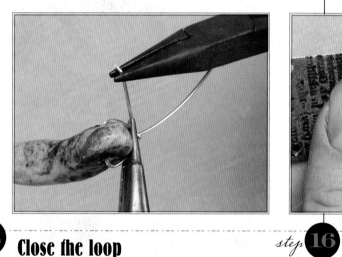

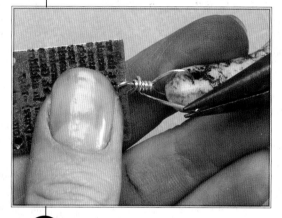

step 15
Close the loop

Wrap the end of the wire around itself.

step 16
Add arm to etched metal

Create a loop with the round nose pliers and thread on the metal piece at the bottom hole. Wrap the excess wire around the base of the loop to close the connection.

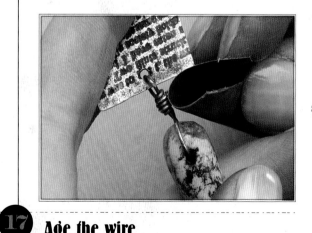

step 17
Age the wire

Brush blackening solution onto the silver wire, let it sit for a minute, then wipe off the excess with a paper towel. Highlight the high areas of wire with sandpaper.

> ### NOTE {to self}
>
> *I lucked out and found a porcelain doll arm with a hole in it already. If you find one without a hole, you can drill a hole carefully using a masonry bit and water.*

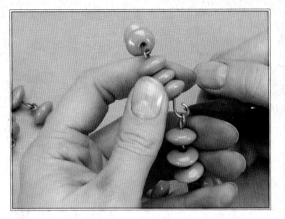

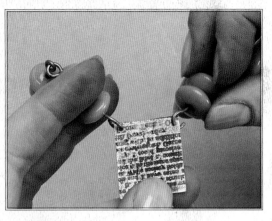

step 18

Disassemble bead necklace

Remove two sections from a blue bead (or other style) necklace, using pliers. One section should contain the hook portion of the clasp.

step 19

Connect beads to metal

Using the loops that are already on the necklace sections, open one up with pliers, thread on the metal piece in one of the corners and close the section with pliers. Repeat for the other necklace section and the other corner of the metal piece.

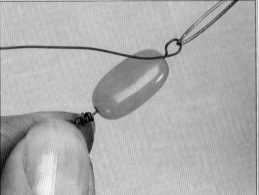

step 20

Add bead and chain

Cut a 4" (10cm) length of black wire and thread on the accent bead. Make a loop using round nose pliers at one end of the bead and wrap the excess wire around the loop. Create a loop at the other end of the bead and then thread one end of the silver chain onto it. Wrap the excess wire around the loop. (Note: My chain was first blackened with blackening solution.)

step 21

Connect bead and chain

Attach the wire-wrapped bead to the section of blue necklace that doesn't have the clasp. Close the loop with pliers.

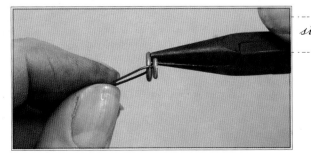

step 22

Finish the closure

Remove one jump ring from the original blue necklace and attach it to the other end of the silver chain to finish.

PAGES PENDANT

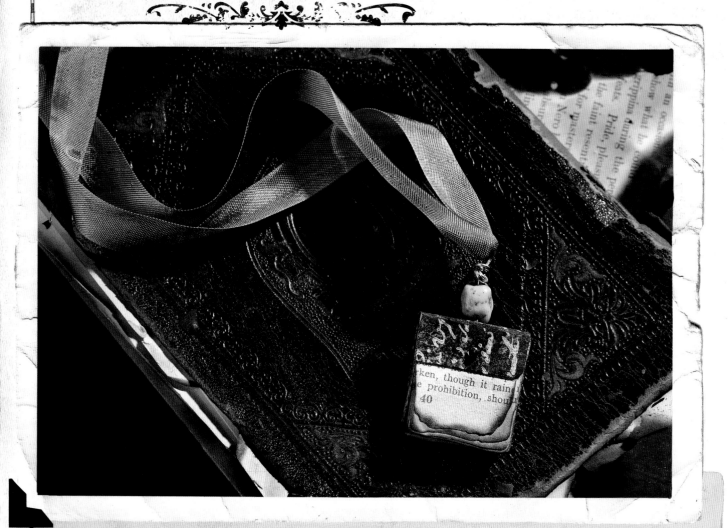

Day 47

SMOKE FILLS THE AIR and we are all wandering about in an attempt to clean up the mess from last night's surprise. Exhausted from the day's labor, two camp mates fell asleep leaving their lantern lit. The movement of a stray arm in sleep knocked it off their bedside table and set the tent ablaze. The tenants were lucky to have been rescued unharmed, though shaken. Startled out of sleep, we all scrambled about in an attempt to keep other things in camp from catching on fire. The dousing of flames became futile as the tent, and all within its walls were ashes within minutes.

The smoke is thick this morning and we have found ourselves digging; not in unfamiliar, mysterious ground, in search of treasures from an unknown origin, but rather through our own belongings in an attempt to unearth any viable remnants of life before the fire. A bundle of books remained salvageable, bound with a leather belt, which apparently hampered all but just the edges of the pages to burn a little. It was a reminder that even in our constant effort to comfortably inhabit our temporary homes, we are still vulnerable to the element of surprise. I'm certain the words on the pages of the surviving books will seem more poignant now when read—a reminder of a close brush with fate and survival of the fittest.

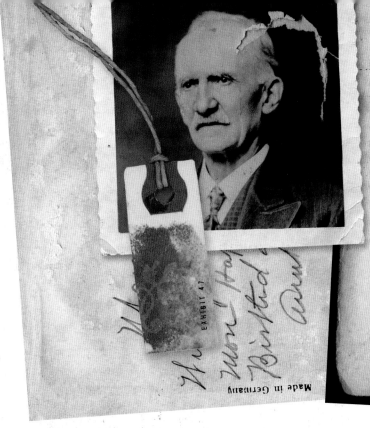

Made in Germany

EXHIBIT 47

Daypack Essentials

REPURPOSING KIT

old book text	sterling silver wire, 18-gauge
scissors	torch
gel medium	turquoise chunk bead
clothespin	brass bolt
matches or lighter	tiny nut and bolt
rubber stamp	
white paint	
brayer	
aged metal	

Gives a ri
While m
CROWN
ladies'

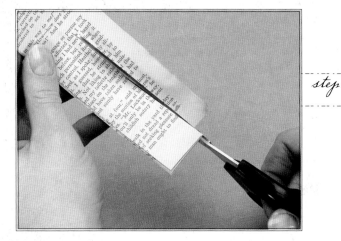

step **1** **Cut strips of text**

Cut about five pieces of old book text pages into 1" (3cm) wide strips.

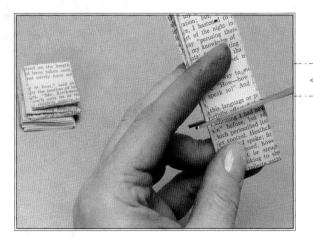

step **2** **Cut squares of text**

Stack the strips to cut several at one time, and cut them into squares that are about 1¼" (3cm) tall.

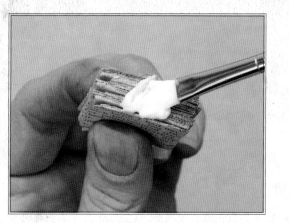

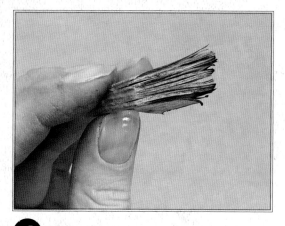

step 3 Glue text stack

Stack enough chunks together until you have a stack about ½" (13mm) thick. Align the tops of the pages so that they are flush (the bottom edges can be ragged) and brush on gel medium. Clamp the stack with a clothespin and set aside to dry.

step 4 Burn the edges

Burn the loose three sides of the paper stack, using a lighter. (Because the stack is so thick a torch is faster but be careful only to burn the edges!)

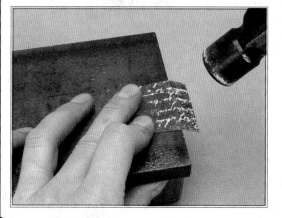

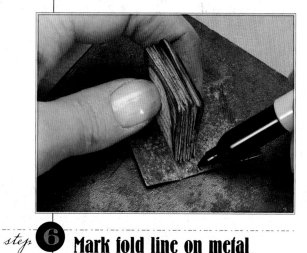

step 5 Bend the metal

Ink up your rubber stamp with a brayer and white acrylic paint. Stamp onto your aged metal. When it's dry, seal it with spray sealer. Using metal shears, cut out a piece that is approximately 1¼" × 1½" (3cm x 4cm). (I just eyeball this.) Hammer the back of the piece flat and file the edges smooth using a metal file. With the metal about ½" (13mm) over the edge, hammer the metal to fold it at a right angle.

step 6 Mark fold line on metal

Straighten the metal back out flat and use the stack of paper to mark where your second fold will go to create the spine of the cover.

> ### NOTE {to self}
>
> *When making a 90° bend in metal, fold it beyond the desired angle and then pull it back out into position. This creates a sharper corner at the bend.*

step 7 Finish the metal fold

Use the hammer and the metal block to make a fold at this mark, then use pliers to rebend the metal at the first line.

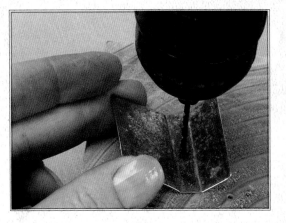

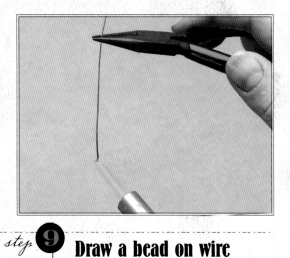

step 8 — Drill hole for bale

Straighten the piece out just a bit then, in the spine section, drill a hole in the center.

step 9 — Draw a bead on wire

Cut a 4" (10cm) length of silver wire and torch the end until a small bead forms. Remove the flame quickly, or the bead may drop off.

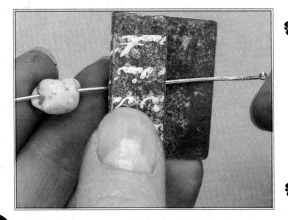

> ## *NOTE {to self}*
>
> *There are two parts to a torch flame: the longer, more transparent outer flame and the shorter, brighter inside flame. To draw a bead, hold the wire in the larger flame, just beyond the tip of the smaller flame until it glows red and pulls up into a ball.*

step 10 — Thread the bale

Let the wire cool and then sand off the black residue with sandpaper. Thread the wire from the inside of the metal cover to the outside and thread on the turquoise bead.

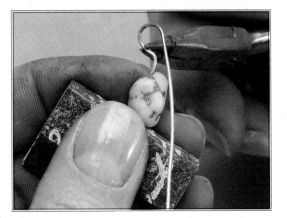

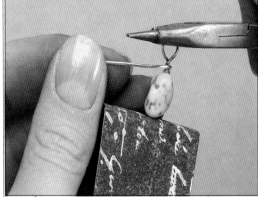

step 11 — Bend the loop for bale

Create a loop above the bead with round nose pliers.

step 12 — Close the loop

Wrap the excess wire around the base of the loop.

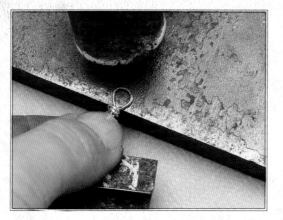

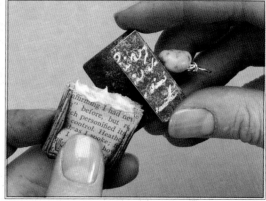

step **13** ## Flatten the loop

Gently hammer the loop flat on both sides. This will strengthen the wire and prevent it from bending out of shape.

step **14** ## Add the paper stack

Apply gel medium liberally to the flush end of the page stack and insert the stack of pages into the metal cover. Squeeze metal closed around the stack. Secure with a clothespin and let dry.

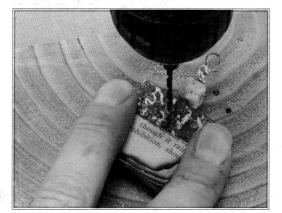

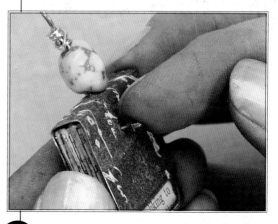

step **15** ## Drill for bolt

Drill a hole through the entire stack, centered on the front of the metal and about ⅛" (3mm) from the edge. (Your bit should be ever-so-slightly larger than the bolt.)

step **16** ## Thread the bolt

Thread the bolt through the hole and secure the nut tightly.

step **17** ## Finish the bolt

Snip the excess bolt off with wire cutters. File the bolt end smooth and then spray the entire piece with spray sealer.

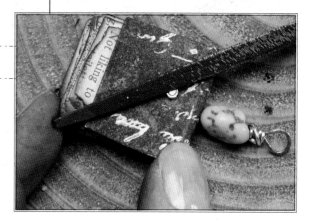

THE MATRIARCH'S ARMLET

Day 56

WE'VE FOUND WHAT WE BELIEVE TO BE THE HOMESITE of a once wealthy or prominent person. We are not finding the usual shards of earthenware, mortar and pestles and basketry, the humble belongings of those who lived fully off the land and depended solely on themselves for nourishment and survival. Rather, we have found various stones, beads and buttons. These are not the accoutrements of a farmer, but perhaps a matriarch or tribal leader. I'm astounded at how many items we are finding in such a concentrated area. Once-complete items of personal decoration are being unearthed alongside the bits and pieces, which leads me to think that they were considered worthy of wearing as status symbols, perhaps. Delicate brass filigree, smooth bone beads, bright glass beads, and even snippets of the clothing they accompanied—all tangled together in a mystery of the past.

Daypack Essentials

↓

REPURPOSING KIT

sterling silver wire,
24-gauge

torch

shell beads, 3

teardrop bead

large bead (threadable on
20-gauge wire)

decorative metal button

vintage sequin button

sparkly beads, 4

velvet/silk scraps

brass wire, 20-gauge

sterling silver wire,
18-gauge

black wire, 24-gauge

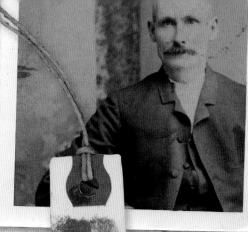

EXHIBIT 25

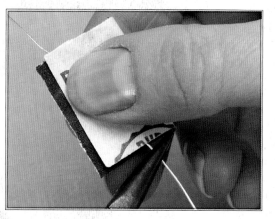

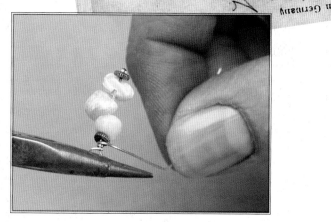

step **1** **Draw a bead**

Start with a 5" (13cm) length of 24-gauge
sterling wire and torch the end of it to
form a bead. Use sandpaper to take off the
black residue.

step **2** **Add shell beads**

Thread the shell beads onto the wire. Create
a loop at the top of the beads, using round
nose pliers, then wrap the excess wire around
the wire. Repeat the wire wrap process for
the drop bead and set the dangles aside.
Repeat this same process for any other beads
and charms you want to attach to the bangle.

NOTE {to self}

*Begin by wire-wrapping the individual beads to
create charms, creating loops at one end for threading
onto the bangle. Preparing all the charms and dangles in
the beginning saves time when assembling. It's fun to see
the combination of the different components before you
have committed them to the piece by attaching them.*

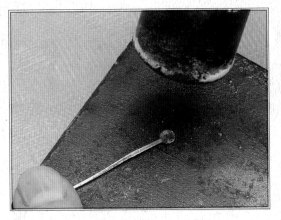
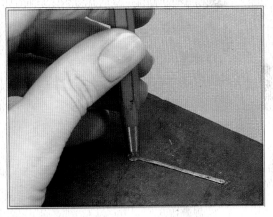

step 3

Hammer large wire charm

Cut a 2" (5cm) length of 18-gauge silver wire
and create a bead on one end, using a torch, as
in step one. Hammer the wire flat to prepare
for drilling.

step 4

Mark for drilling

File the end of the wire if it's sharp. Use
a center punch to mark the center of
the flattened bead on the wire.

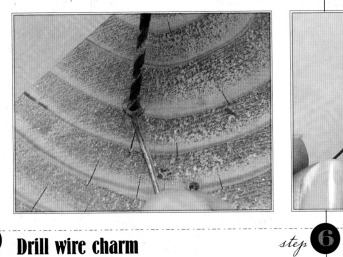
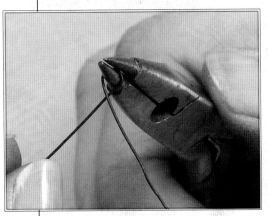

step 5

Drill wire charm

Using a very slow speed, drill a hole at the
mark.

step 6

Create loop for wire charm

Cut a 4" (10cm) length of black wire
and, using the round nose pliers, make
a loop at one end.

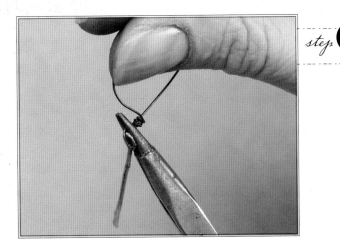

step 7

Add wire charm

Thread the wire dangle onto the loop
in the wire, then wrap that end around
itself. Make a second loop above the
wrap and wrap the excess around the
wrap again.

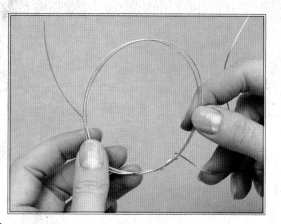

step **8** ## Create bangle form

Trim off about 5' (152cm) of brass wire. Create
a couple of loops in the wire that will be large
enough to fit over your hand. Leaving about a 2"
(5cm) straight end, create a couple more loose loops
and then wrap the wire around itself. (I intention-
ally don't make all of the loops exactly the same
diameter for added interest.)

step **9** ## Add focal point bead

Continue making loops and randomly placing
wraps around the wire. After you have secured
the wire in a couple of places, begin weaving the
wire between loops in places. When you have
about 24" (61cm) of wire left, begin incorporat-
ing your beads and dangles. Start with the large
bead and thread it onto the wire. Wrap the wire
around the loops once or twice to secure it.

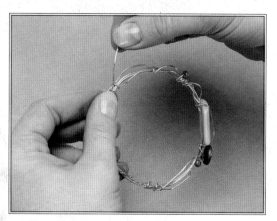

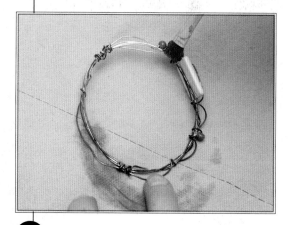

step **10** ## Add button and small beads

Thread the decorative button onto the wire and
a small bead. Secure with another wrap or two
of wire. Make one more loop around the bangle,
wrap the wire several more times on the opposite
side of the large bead. Trim the excess and, using
pliers, bend the end into the loops. Wrap the
remaining end of wire.

step **11** ## Age the bangle

Working on a paper towel, brush blackening
solution over the wire. Be sure to brush both
sides of the bangle. After the brass has started
to blacken, wipe off the excess solution with
a paper towel.

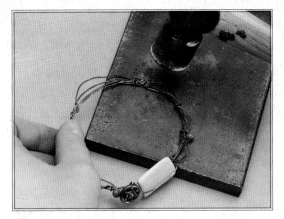

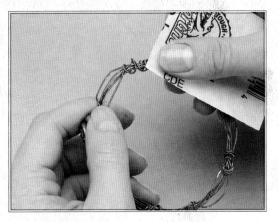

step 12
Hammer bangle

Working on a metal block, hammer both sides of the bangle a bit to flatten parts of it creating texture, interest and strength.

step 13
Sand for highlights

Lightly sand the flattened bangle with sandpaper to highlight the raised areas.

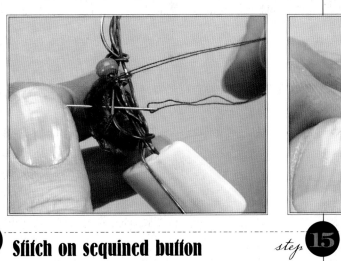

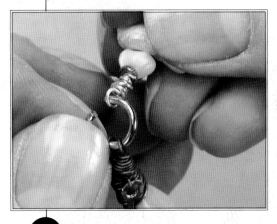

step 14
Stitch on sequined button

The sequin button that I am adding here no longer has a shank, but since it was backed in felt, I can stitch it on with a needle and thread, securing it to the wire with several passes of the needle.

step 15
Add charm cluster

Add the final dangle elements to a jump ring. Thread the open ring onto the loop of a dangle.

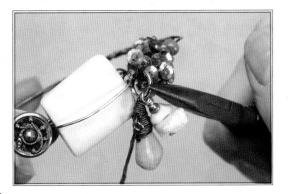

step 16
Secure charm cluster

Secure the ring to the bangle where you want it using pliers to close the jump ring.

step 17
Add ribbon and silk

Finally, tie on scraps of silk and/or velvet ribbon at spots where you'd like to add interest.

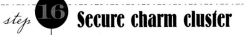

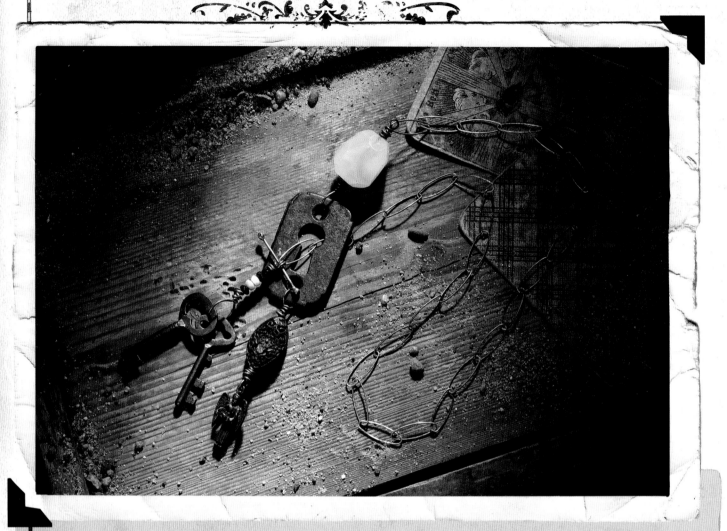

Day 72

THE DWELLINGS OF THE PEOPLE WHO ONCE LIVED at the location we are currently excavating were simple structures of cob, stone and wood. They are all basic structures, most with a single room that an entire family would have shared. No doors to be closed and no threat of intruders.

Yet we have found one structure much different than the rest. It appears that it was relatively quite large and more important than the humble homes of the village. As we have been unearthing the walls of this structure, we have found statuary of seemingly spiritual significance. Perhaps this was a temple of sorts; a place for the people to offer up prayers for an abundant harvest, protection from harsh weather, or healing for their sick.

In such a distinctive structure, it was not surprising to find the only evidence of protection—a ring of keys that must have opened the doors of this sacred place. The doors have not survived but the keys remain—evidence of the value they placed on this structure and the significant role it must have played in their lives of adaptation and survival.

Daypack Essentials

↓

REPURPOSING KIT

brass wire, 20-gauge

angel charm

large beads, 2

keyhole plate (with a hole on the top and the bottom)

1/2" (13mm) dowel

antique keys, 2

sterling silver wire, 18-gauge

torch

silver chain, 18" (46cm)

small beads, 5

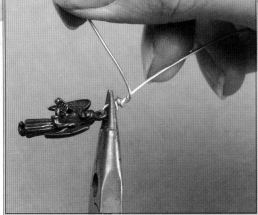

step **1**

Hang angel charm

Cut a 6" (15cm) length of brass wire and create a loop about 2" (5cm) from one end. Thread on the angel charm and wrap the excess short wire around the base of the loop.

step **2**

Add bead to angel charm

Thread one large bead onto the unwrapped end of the wire on the angel charm and then create another loop at the other end of the bead. Thread the loop onto the bottom hole in the keyhole plate and then wrap the remaining wire around the base of the loop to close it off.

NOTE {to self}

The key (no pun intended) to this necklace wearing well is balance. The keyhole end of the necklace must have enough weight to it, to pull the toggle end of the necklace up and snug against the keyhole plate. Using weighty beads above and below the keyhole plate assures good balance.

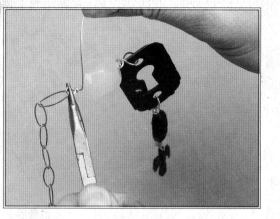

step **3** ## Add large bead

Cut another 6" (15cm) length of brass wire and create a loop about 2" (5cm) from one end. Thread the top hole of the keyhole onto the loop and wrap the short end of the wire around the base of the loop to close it off. Thread the second large bead onto the wire, create a new loop at the top of the bead, and thread the silver chain onto the loop. Wrap the excess wire around the base of the loop closing it as well.

step **4** ## Loop and flatten wire

Cut a third length of brass wire to 6" (15cm) and wrap it around a large dowel to create a large loop, about 2" (5cm) from the end. Lightly hammer the loop to flatten it.

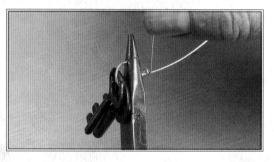

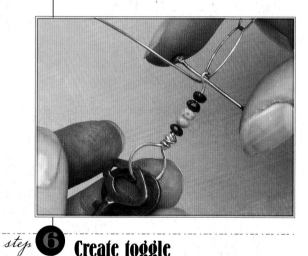

step **5** ## Add keys

Thread on the two keys and then wrap the short end back around the wire to close the loop.

step **6** ## Create toggle

Cut a 2" (5cm) length of sterling silver wire and draw a bead on each end of it, to create a toggle. Each bead uses up about ½" (13mm) of the wire so 2" (5cm) allows for losing 1" (3cm) for the beads. Thread the five small beads onto the unwrapped end of the brass wire, then create a tiny loop that is just large enough to comfortably fit the toggle. Push the toggle into the loop and then thread on the other end of the silver chain. Wrap the wire around the toggle and through the chain link end one more time.

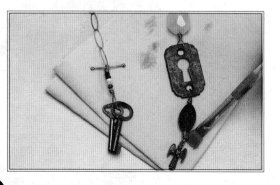

step **7** ## Age the necklace

Wrap the excess wire around the base of the loop. Apply blackening solution to all of the brass wire and wipe off the excess to finish.

ODD-COUPLE EARRINGS

Day 86

WE HAVE SEVERAL GUIDES WITHOUT WHOSE HELP on this expedition we would
be burdened with so much more than we could handle ourselves. They are familiar with the land, duti-
fully guiding us to our destinations, and keeping us protected through their knowledge. They selflessly do
more for us than just perform the required duties for which they are paid. I've grown fond of them all,
but particularly of a husband and wife who are young and energetic. An odd pairing, he is quiet and gen-
tle and she is outgoing and animated. They both wear the clothing of their people—layers of free-flowing
linens and strands and strands of beads. (Bright green turquoise, worn by the woman, mimics
the color of her eyes.) They flit around camp, keeping us all well-fed and cared for as much as possible,
considering our accommodations. What fun it is to watch such an odd couple who are so different love
each other so simply. Their playful interaction is a boost to our morale.

REPURPOSING KIT

nickel etched in the acetone method
(see pages 27–28), large enough to
cut two small pieces

sterling silver wire, 20-gauge

torch

turquoise chunk beads,
2 (threadable on 20-gauge wire)

cut glass beads, 2

EXHIBIT 8.6

NOTE {to self}

Because etching is a messy process,
I often etch more metal than I need for
the particular project I'm working on.
I save all the scraps and snippets for
projects like these asymmetric earrings.

 step 1 — Cut focal point metal

Using metal shears, cut a vertical piece that
is ½" × 1" (13mm × 3cm) and a horizontal
piece that is 1" × ¾" (3cm × 19mm) from
a piece of nickel that has been previously
etched with text.

step 2 — Drill pieces

Hammer and file the pieces. Drill one hole into
the top of the vertical piece, and a hole at the
top and at the bottom of the horizontal piece.

 step 3 — Create ear wires

Cut two 4" (10cm) lengths of sterling wire.
So the two earrings are symmetrical, bend the
pieces simultaneously around a dowel.

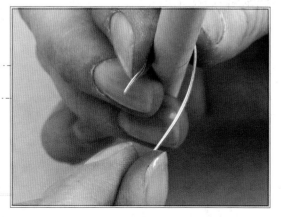

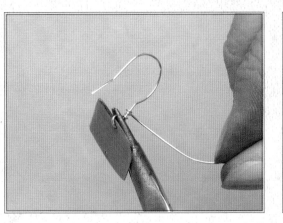
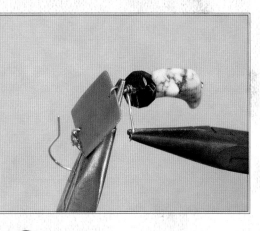

step **4**
Attach ear wire to metal

Create a loop at the end of the bend in the wire, and thread the horizontal piece onto the loop. Wrap the wire around the top of the loop.

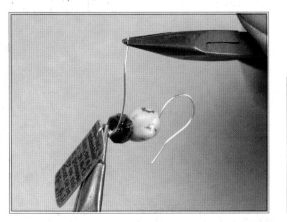

step **5**
Thread beads on wire

Hammer the ear wire lightly on both sides to help it keep its shape. Torch the end of a 2" (5cm) length of wire to create a bead, which will act as a head pin. File the bead if necessary. Thread a turquoise bead onto the wire, then a glass bead. Create a loop, insert the wire into the bottom hole of the metal piece and wrap the wire around the base of the loop.

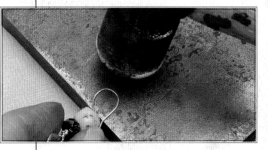

step **6**
Add beads to second ear wire

Thread a turquoise bead onto the other ear wire, then the other glass bead. Make a loop at the bottom of the bead and thread on the vertical metal piece. Wrap the wire below the loop. To keep the turquoise bead from sliding off over the wire, kink the ear wire just above the bead to create an angle the bead can't slide over.

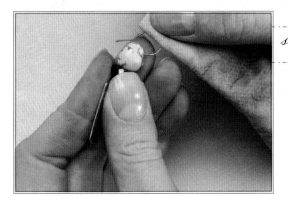

step **7**
Flatten ear wire

Hammer the ear wire lightly to flatten it holding the ends together to keep it from opening up.

step **8**
Finish the wire

File and sand the ends of the ear wires so they're not sharp. Brush blackening solution onto the ear wires and remove with a paper towel. Lightly sand the wires if needed to even out the tone. (Note: For sensitive ears, apply a quick coat of spray sealer.)

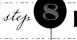

LIVES-ENTWINED BRACELET

Day 94

MARKET DAY—a day of spectacular color, scents and sounds. I've been here on a few occasions and have taken note of the familiar faces from behind the displays of goods. The same men and women are always offering the fruits of their labors in hopes of earning a fair wage for the day. The chaos of the streets invigorates me and I find myself lingering longer than perhaps I should. I am amazed at the attention to detail and the fine craftsmanship of the wares.

The artisans stand for hours in the heat shaded only by a cloth suspended from the eaves of an adjacent building. When they have no customers they visit with each other, bartering and trading goods. The seamstress trades a box of buttons for a bead merchant's spring-hued beads. The woodworker barters his goods for silver chain from the silversmith—perhaps a gift to his wife. Their lives are intertwined; they rely on each other for acquisition as much as on patrons such as myself.

Made in Germany
March
Wish you w
won't for
Birthd a
EXHIBIT 94

Daypack Essentials

↓

REPURPOSING KIT

sterling silver wire,
18-gauge

small shell buttons

torch

brass wire, 20-gauge

stringing wire and
crimp beads

various beads

black wire, 24-gauge

resin charm

spent bullet casing

silver chain

Gives a rif
While m
CROWN
ladies'

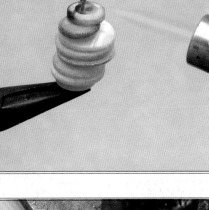

step **1**

Create button segments

Cut four 2" (5cm) lengths of silver wire. Draw a
bead on the end of one wire, then thread ten shell
buttons onto the wire. Holding the stack with
the pliers, draw a bead on the other end. When
drawing the second bead, turn your flame low to
create a smaller flame. Hold the flame just over the
top of the wire to minimize heating up the buttons.
The buttons *will* heat up and sometimes burn a bit,
but that just adds character to the piece.

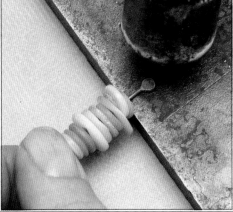

step **2**

Hammer beaded ends of wire

Hammer the beads on each end. The area needs to
be big enough to drill a hole in with your ¹/₁₆" (2mm)
drill bit.

POSTCARD

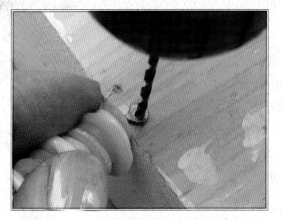

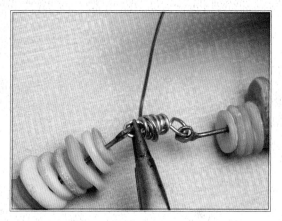

step **3** ## Mark and drill hole

step **4** ## Connect button segments

Mark for a hole at the center of each bead with a center punch. It is critical to center this mark as accurately as possible to prevent drilling through the side of the flattened area. Drill a hole at each mark. Repeat steps 1–3 to create a total of four button segments.

Cut an 8" (20cm) length of brass wire. Create a loop about 1½" (4cm) from one end and thread on one of the button links. Wrap the excess wire around the base of the loop and create a second loop and connect another button link. Wrap the rest of the wire back around itself to create a bulky wrap. Repeat two more times to connect all of the button links.

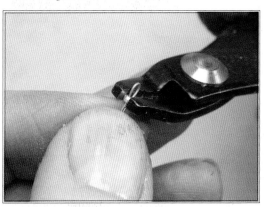

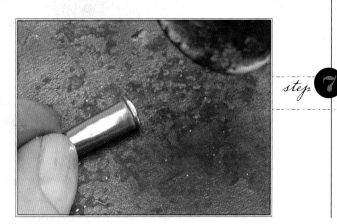

step **5** ## Start beading wire

step **6** ## Add beads

Blacken all of the brass wire and sand it lightly to highlight the raised areas of the wrapping. Cut 8" (20cm) of beading wire and on one end, thread a crimp bead. Make a small loop and thread the wire back through the crimp bead, then use crimping pliers to flatten the bead.

Thread on enough beads to create a 7½" (19cm) strand of beads. In this strand I included one resin-filled charm (see pages 22–23), one large faceted stone bead and various smaller beads. Thread on another crimp bead, create another small loop, feed the wire back through the crimp bead and the last bead. Crimp the crimp bead with the pliers to secure.

step **7** ## Hammer bullet casing

To create a bullet casing charm, begin hammering the casing on a metal block. Hammer one side a few times, then turn it over and hammer the other side a few times. Turning the piece over after a few pounds prevents it from cupping.

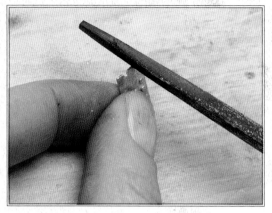

step **8**

Add texture

Then add decorative detail using a nail or center punch, hammering small dents into the casing. This step causes the casing to curve up a bit so hammer it from the other side again to flatten it back out.

step **9**

Finish casing charm

To create a scalloped edge, use a triangular file to sculpt the shape.

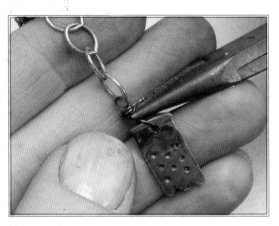

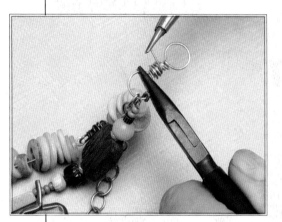

step **10**

Add charm to chain

Blacken the charm, sand it and then drill a hole at the top of it. Blacken an 11" (28cm) length of silver chain and wire-wrap the bullet casing charm to one of the links.

step **11**

Connect the strands

Cut an 8" (20cm) length of brass wire. Create a loop at one end, wrap the short excess around the loop, create a second loop and thread on the three separate strands—the buttons, the silver chain and the various beads. Hammer the end loop slightly to flatten it for strength.

step **12**

Braid the strands

Wrap the excess wire around on itself to create a lumpy wrapping. Very loosely braid the three strands, leaving a bit more slack in the chain than the other two strands.

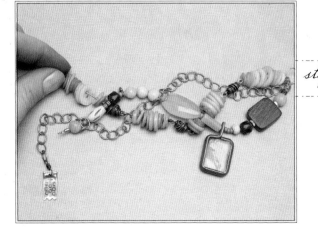

step **13** ## Create hook closure

To create a brass wire hook, cut a 12" (30cm) length of wire. Bend the wire in half and hammer the tip just a bit.

step **14** ## Bend hook

Bend the hammered portion into a close hook.

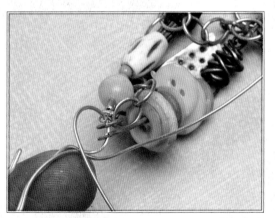

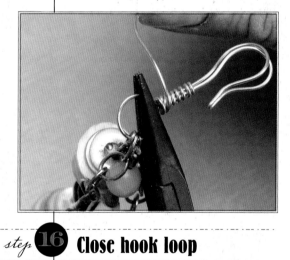

step **15** ## Attach hook to strands

Bend one of the ends into a loop and thread on the other ends of the three strands.

step **16** ## Close hook loop

Wrap the excess wire from the loop around the base of the loop. Now, wrap the second loose end around the same wrap.

step **17** ## Strengthen hook

Lightly hammer the loop at the end of the bracelet. Blacken the two brass wire ends to finish.

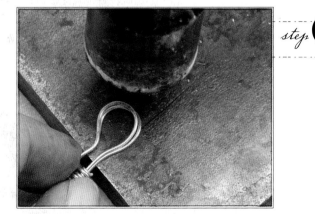

CAUGHT EARRINGS

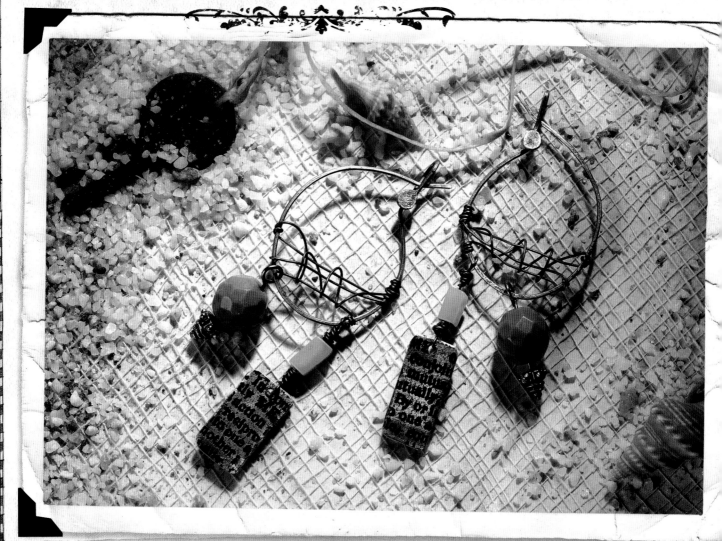

Day 102

THE RAINS HAVE BEEN PLENTIFUL THIS YEAR, keeping the water levels high. The local fishermen are having no trouble filling their boats and we are enjoying the fare their efforts provide.

They used to bring their catch flung over their backs to camp, but of late, we have had to venture into their village to purchase what we want from them. They are too busy with the abundance to take the time to deliver our portions. We went this morning to greet them as they grounded their boats, anxious to choose the fattest catch. Passing the fishermen's homes, we were serenaded by the whirring whisper of the wind blowing through the tangled lines hung from poles along the dirt road that leads to the water. By the looks of things, they catch more than just fish. Many unknown objects dangled from the lines and I was intrigued by the fact that one man's discards had become another's ornament.

Daypack Essentials

↓

REPURPOSING KIT

silver decorative head pins, 2

beads, two styles, one small,
one larger, 2 ea.

black wire, 24-gauge

previously etched square dangles,
2 (see page 46)

torch

sterling silver wire,
18-gauge

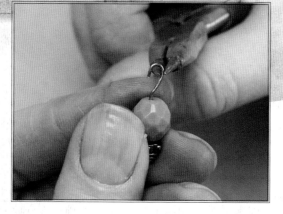

step **1** **Create bead charm**

Thread one larger bead onto one decorative head pin and, using round nose
pliers, create a loop at the end of the pin. Repeat for the other head pin.

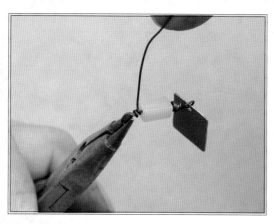

step **2** **Create etched metal charm**

Cut a 4" (10cm) length of black wire and create a loop at one end, using round nose
pliers. Thread on one etched metal square and wrap the wire around the base of the
loop. Thread on one small bead and create a second loop at the end of it, wrapping the
excess wire around the base of the loop. Repeat with a second length of wire.

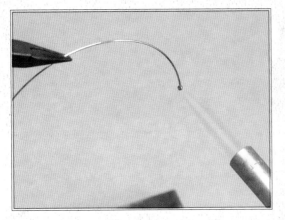

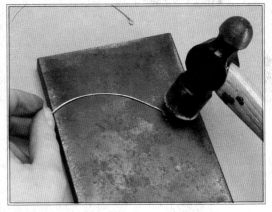

step ③ Draw bead on wire

Cut a 5" (13cm) length of silver wire and using a torch, create a large bead on the end of it.

step ④ Flatten bead

Sand the bead and wire. If the wire is curved still, don't try to straighten it. Hammer the bead as well as about ½" (13mm) of the wire above it, using a hammer on a metal block.

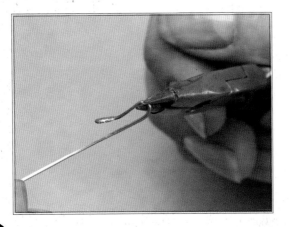

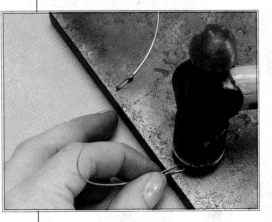

step ⑤ Bend loop catch

Using pliers, bend the wire below the bead, to create a loop for a closure.

step ⑥ Repeat for second earring

Hammer the loop lightly. Repeat steps 3–5, reversing the direction of the bend in step 5, for the second ear wire.

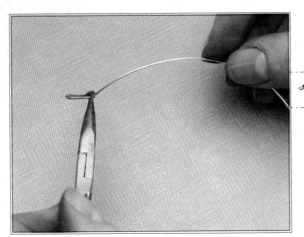

step ⑦ Define closure hook

Bend the wire back a bit at the base of the closure to define where the closure end is.

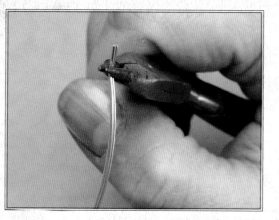

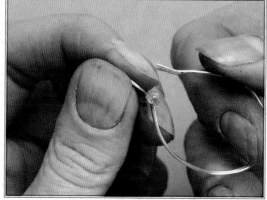

step **8** Bend into earring shape

Hold the two wires together and trim them to the same length. At the end of each wire, make a bend about ¼" (6mm) from the end.

step **9** Curve earring shapes

Hammer the ends lightly to flatten. Working a small section at a time, carefully bend the wires into the desired loop shape.

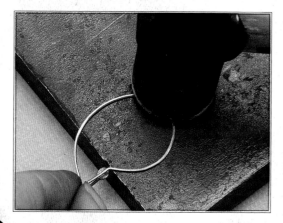

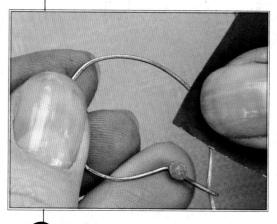

step **10** Finish loop shape

Continue working the curve until the kinked ends fit snugly into the hook ends, and will stay when hooked together. With one earring hooked together, lightly hammer the loop. Repeat for the second earring.

step **11** Age the loops

Blacken the loops with blackening solution and lightly sand with 400-grit sandpaper to even out the finish.

step **12** Add the charms

Thread one etched piece onto one of the ear wires, so that it's facing front, then thread on a bead piece. Cut a 12" (30cm) length of black wire. Create a tiny hook in one end of the wire and hook it to the lower portion of one wire.

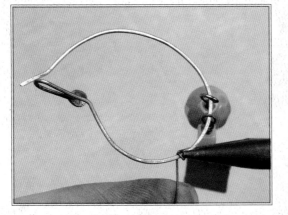

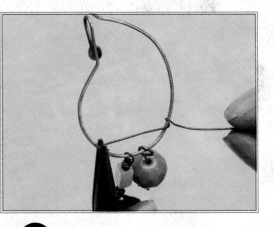

step 13 ## Secure wire for wrapping

Crimp the wire to secure it, then wrap it around the loop a few times crimping again to secure it.

step 14 ## Start the wire wrapping

Holding the wire at the wrap with pliers, wrap the wire across the loop and then around the ear wire a couple of times to secure it.

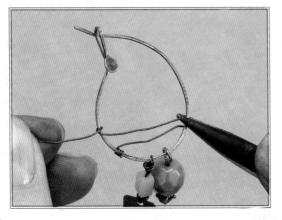

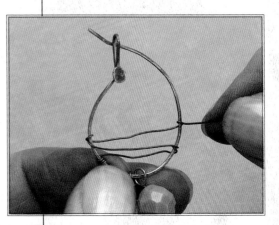

step 15 ## Continue wire wrapping

Bring the wire back across to the first side again, but a bit higher and secure it again by wrapping it around the ear wire a couple of times.

step 16 ## Finish wire wrapping

Bring the wire back to the other side and again, secure with a couple of wraps.

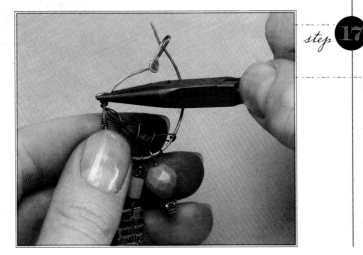

step 17 ## Create the "caught" look with the wire

Now, begin wrapping the wire around the wires that have crossed the loop, to create the "caught"/cage look. Make two or three loops. Secure the wire around the ear wire, trim the excess and crimp the wire with pliers to secure. Repeat for the other ear wire. Sand or file the ends of the wire if needed so that they're not too sharp to put in your ear.

BIRD NEST RING
AND EARRINGS

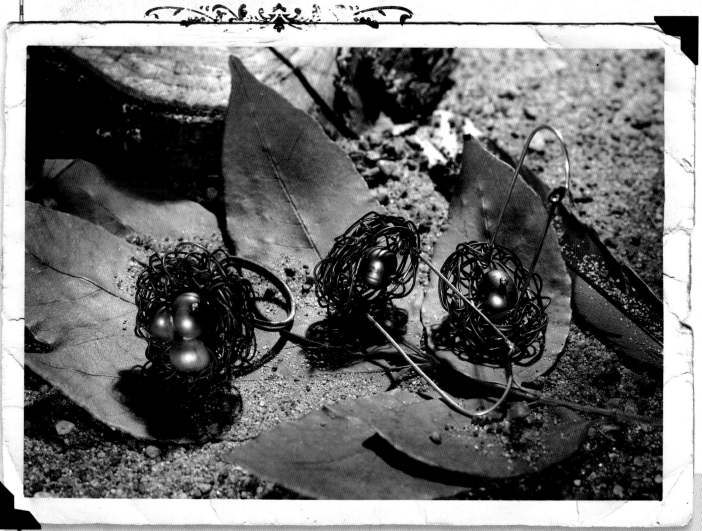

Day 1-10

WE'VE BEEN EXCAVATING in a thick grove of trees. It's been a relief to have shade and find our endurance extended, resulting in longer days of comfortable labor. We have not found much of major significance, but have found ourselves the target of a nesting bird's frustrations. We must be making too much racket for her to peacefully build her nest. In the echo of her petulant squawking and daredevil swooping at our hats, we found our patience tested and left camp for the day.

Upon our return this morning, I was instantly aware of the quiet of the canopy. No squawking. No swooping and screeching. Despite her annoying antics, I found myself hoping she was nestled in somewhere, resting and readying herself for motherhood. I happened to glance up and catch sight of her leaving a branch not far above me. In a plucky spurt of youthfulness, I clambered up the tree to scout out her new home. I found a tiny nest made of grass, twigs and the string I used to tie my hair back with, and which I thought had been lost in the dirt. Within lay three vivid blue eggs. I wanted to pick them up and feel their silky smoothness but I knew better than to disturb her home. The moment of observation was cut short by her return. Not wanting to feel the sharp end of her anger, I shimmied down the tree just as she discovered my presence. She swooped at me and I jumped the last few feet taking shelter under the cover of the dig site tent, not a moment too soon. She retreated to her nest leaving a few exasperated screeches in the air. Truce.

↓

REPURPOSING KIT

sterling wire, 24-gauge

torch

freshwater pearls, 5

sterling wire, 18-gauge

copper wire, 22-gauge

large paintbrush or dowel

EXHIBIT I-10

Made in Germany

Gives a ri
While m
CROWN
ladies

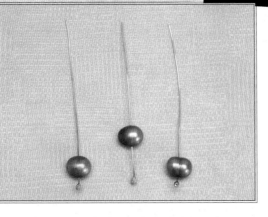

{RING}

step 1

Thread the "eggs"

Cut three 3" (8cm) lengths of 24-gauge silver wire. Draw a bead on one end of all three lengths. Sand the beads lightly, then string one pearl on each piece.

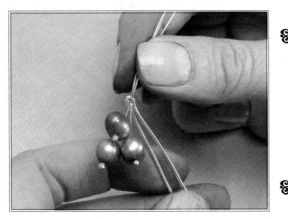

NOTE {to self}

Because freshwater pearls are somewhat soft inside, if the holes aren't quite big enough for the wire, you can enlarge the holes with a pearl reamer.

step 2

Add the ring shaft

Cut a 6½" (17cm) length of 18-gauge sterling wire and bend it in half, creating a small opening. Thread all three pearl wires through the opening.

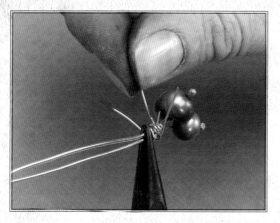

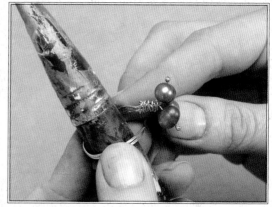

Secure the "eggs"

Wrap each pearl wire around the folded wire, just below the opening, a couple of times for each. Make sure to wrap snugly against the pearls to keep them from sliding away from the wire-drawn bead.

Create ring form

Curve the folded wires around a large dowel or paintbrush to create the ring form, then adjust it as necessary to the size you want.

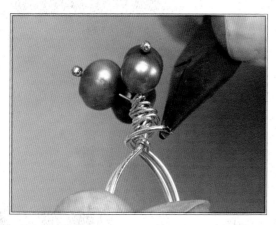

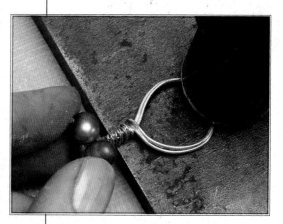

Close ring form

Wrap the ends of the wire back around the base of the pearl wrap.

Hammer ring

Hammer the ring on a metal block to flatten it.

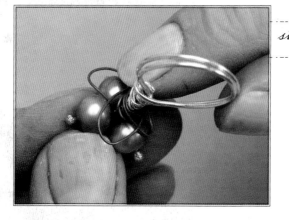

Begin the nest

Cut a 4' (1m) length of copper wire and wrap one end around the pearl wrap to secure it. Begin forming "petals" around the pearls by making a loop, wrapping it around and then making another "petal," to begin forming the nest.

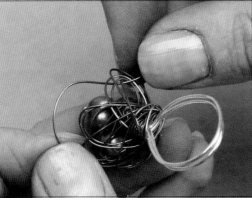
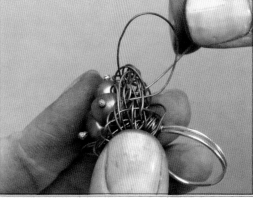

step 8 — Add to the nest

Continue making petal shapes, with each new row of "petals" getting larger as you go around. Make about five of these rows to create the basic bowl shape that will become the nest. Then, begin weaving the wire randomly in and out of the loops as you work around the pearls.

step 9 — Fill in the nest

Keep weaving around, randomly picking up different sections of the nest as it builds and continue until the nest has the fullness you want it. When you run out of wire, tuck the end in and crimp it, and start with a new length, securing it with a crimped hook to start. Lastly, create tie loops that wrap around the wires vertically, loosely securing the larger wraps and creating additional dimension and strength.

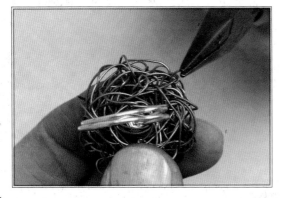

step 10 — Finish the nest wrapping

Continue looping the wire vertically until the nest looks finished. To finish with the wire, just make a couple of small loops and tuck the end in.

NOTE {to self}

For added interest, mix metals and gauges of wire. Brass, silver, copper and annealed iron wire all work well for the nest form. Only copper and silver will allow you to draw a bead onto it so it's a good idea to start with one of those to thread the pearl onto, then add the other wires as you are weaving the nest.

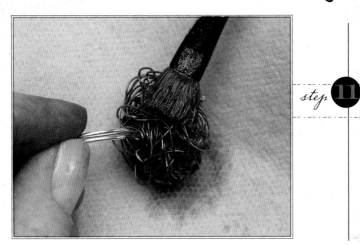

step 11 — Age the ring

Brush on blackening solution. Let it sit for a moment and then wipe off the excess. If desired, lightly sand parts of the nest with 400-grit sandpaper to highlight areas.

{EARRINGS}

Draw bead on ear wire

For the earrings, begin by cutting two 5½" (14cm) lengths of 18-gauge sterling wire. Draw a large bead on one end of each piece. Hammer each bead flat and mark and drill a hole in each. Straighten the wire as much as possible. From the bead end, measure down 1½" (4cm) and bend the wire at a 90° angle. Then at another ½" (13mm), make a second 90° bend.

step **2** **Shape the ear wire**

Create a curve in the wire at about 1½" (4cm) up from the last bend, using a dowel or paintbrush.

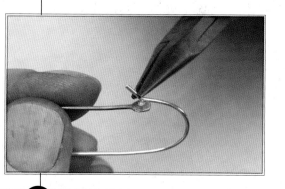

step **3** **Trim the ear wire**

Bend the end of the wire so that it meets up with the drawn bead. With the wires overlapping, trim the end to about ¼" (6mm) below where the bead is on the other end of the wire.

step **4** **Create closure bend**

Kink the end of the wire a bit, slightly above where it will go through the hole in the drawn bead and make sure it will insert into the hole easily.

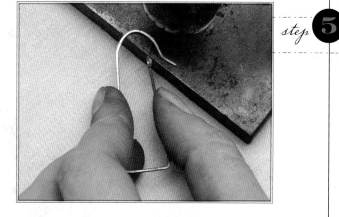

step **5** **Finalize ear wire shape**

Insert the end of the wire into the hole in the bead and lightly hammer the wire. When you come to the area where it hooks together, remove the wire from the hole and hammer the wire end a bit too. File the tip of the wire to remove any sharpness.

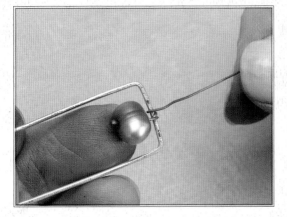

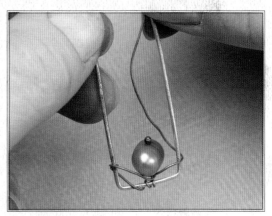

step **6** ## Add "egg"

Cut a 2" (5cm) length of copper wire and draw a small bead on the end of it. Thread the wire through one of the pearls and then wrap the wire around the horizontal portion of the ear wire. Hold the egg away from the bottom of the ear wire just a bit to allow for the nest to be built up under it.

step **7** ## Secure the "egg"

Bring the wire up even with the pearl and wrap it around one side wire, back around the wire the pearl is sitting on, then back up and around the wire on the other side. This will prevent the pearl from tipping.

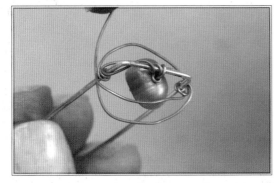

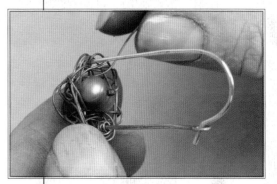

step **8** ## Start forming nest shape

Now, take the wire back to the other side and wrap it around the opposite wire, leaving a loop. Repeat, going back to the other side again, leaving another loop. Repeat this process until you have about four or five loops making each loop a little larger than the one before. Keep in mind that the finished nest will be slightly larger than this form so make it a little smaller than you want it, initially.

step **9** ## Weave the nest

Like in the ring, start weaving the wire through the loops and in random directions to form the nest. Leave plenty of space outside of the pearl, and periodically loop the wire around the silver wire at the bottom and on the sides. Cut a second length of wire if you need it, securing the old and new ends by crimping them discreetly inside the nest. Continue wrapping until the nest is as dense as you would like it.

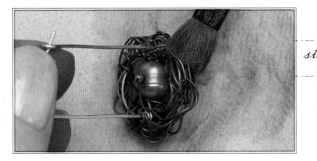

step **10** ## Patina the earrings

Finally, brush on blackening solution. Let it sit for a bit, then wipe off the excess, sanding lightly to highlight raised areas, if desired.

GUARDIAN CUFF

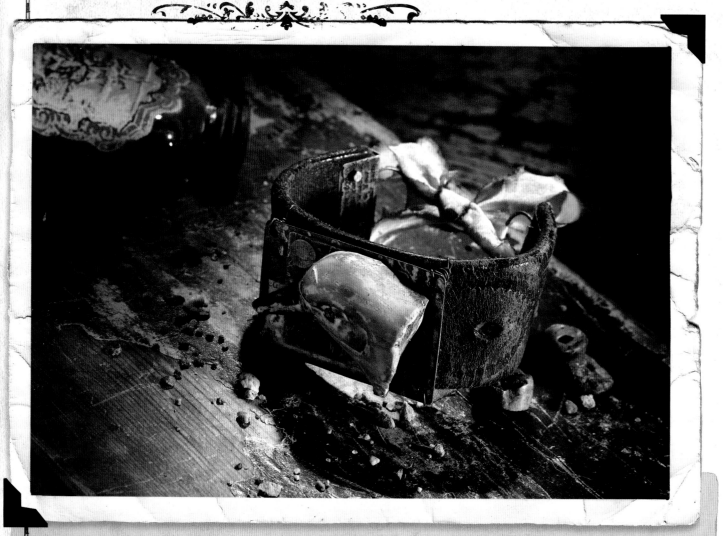

Day 119

TODAY PRESENTED A MOST MYSTERIOUS FIND. One would think that because we don't know specifically what we are digging for, that everything we find would be mysterious. This is not the case as many unearthed objects are self-apparent (a spoon, pottery or a piece of jewelry).

A reliquary of sorts, not much larger than my hand, was found in an empty chamber. Considering the material it was made of, it was surprising that it had survived for so long. Leather—thick, dark, oiled leather. Not a likely material to find preserved so well. It was crafted with precision joinery, which I have not yet been able to identify. On the lid, a beautiful carved bird stands sentinel over what may lie within. It is empty and my mind wanders, imagining what could have been deemed valuable enough for such a hiding place. Where did the box come from? A trader from a neighboring village, a sailor from another land? How very curious.

Daypack Essentials

↓

REPURPOSING KIT

Sculpey brand clay (use the white, "oven-dry" variety but do not bake it)

bird form (such as a plastic or wood toy or ornament)

torch

vintage leather belt

permanent marker

plaster of Paris, 2-3 tablespoons

wood glue

pre-etched nickel sheet

tiny nuts and bolts, 4

book text

gel medium

black wire, 24-gauge

acrylic paint and paintbrush

clear caulk

silk ribbon scraps

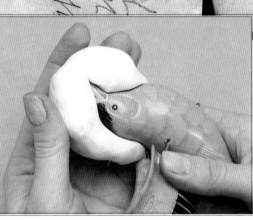

step **1** ## Condition clay

Condition a lump of clay and press the head portion of a bird into the clay. Gently remove the bird head revealing a clean impression to cast plaster into. Only press the head halfway into the clay to create a nice, flat back on the finished bird head.

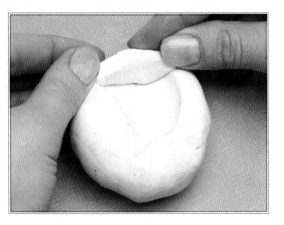

step **2** ## Create casting well

Seal off the open side with additional clay, to create a complete enclosure for the plaster.

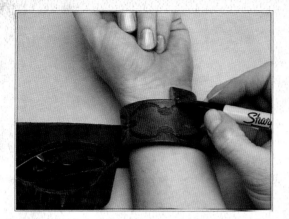

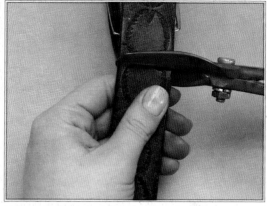

step ③ ## Fill the mold and size the cuff

step ④ ## Cut the leather

Mix a slightly runny consistency of plaster of Paris. Add about ⅛ tsp. of the wood glue to the dry plaster, then a small amount of water. Mix vigorously to cream out any lumps. Slowly add more water until the plaster is the consistency of buttermilk. Fill the mold half full of the plaster then tap the mold against the table a few times to bring any bubbles to the surface. Fill the rest of the way and set aside to cure. Measure the circumference of your wrist and mark it on the belt.

Cut the belt 1" (3cm) shorter than where you marked it with the pen to allow for the addition of the closure.

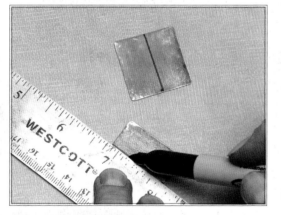

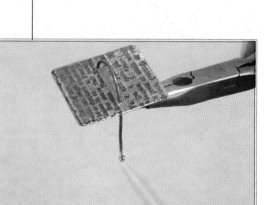

step ⑤ ## Cut etched pieces for closure

step ⑥ ## Add wire loops

Cut two pieces of etched nickel sheet 1⅛" (3cm) × whatever the width of your belt is minus ⅛" (3mm). So, for example, if your belt is 1" (3cm) wide, cut each piece of nickel to 1⅛" × ⅞" (3cm × 2cm). Hammer the metal pieces and file the edges, removing any burrs and the sharp corners. Draw a line on the back of each piece, down the center of the 1⅛" (3cm) length.

Using the center punch, mark a hole on the line at ¼" (6mm) from each end. Do this for both pieces. Drill holes at the marks and tap the backs of the holes with a hammer. Cut two 2" (5cm) lengths of 18-gauge sterling wire. Draw a bead on the end of each piece. Thread one wire through one of the holes from the back. Create a loop and thread it through the other hole, then draw a bead on that end. Repeat for the other wire and metal piece.

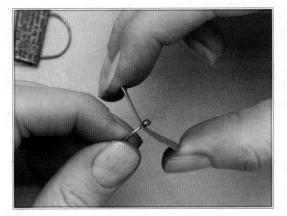

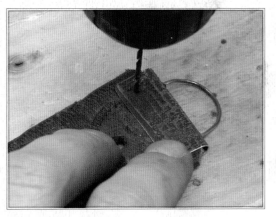

step 7 Fold metal end caps

Fold the metal pieces in half along the line where the holes are.

step 8 Mark end caps for drilling

Push the folded metal pieces onto the ends of the leather. Mark for two holes, using the center punch, ¼" (6mm) in from each bottom corner. Drill at one of the holes.

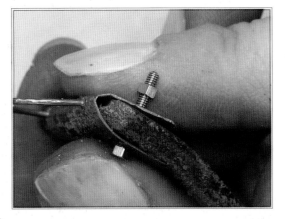

step 9 Secure end caps to leather

Insert a bolt from the inside to the outside and secure a nut onto the end of it. Tighten it just enough to make contact. Drill the other hole, insert the other nut and secure its bolt. Tighten both of the bolts. Repeat for the other end of the cuff.

step 10 Remove plaster from mold

Snip off the excess bolt lengths and file the burrs. Soak the cuff in water for a minute, then remove it and use a clothespin to secure the cuff together while it dries. When the plaster has set, remove the bird from the clay mold.

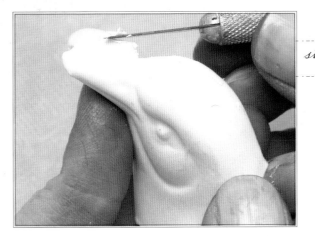

step 11 Clean up the cast plaster

After a few hours in the warm summer sun, 10-15 minutes in an oven set on its lowest temperature or a day or so in room temperature, the plaster will be completely cured. Use a craft knife to scrape away the excess plaster seam.

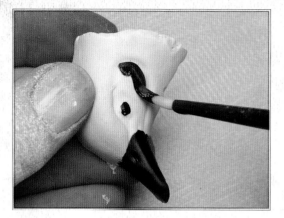

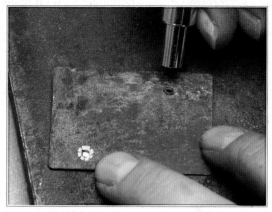

Paint the bird head

Use the Dremel and the wire brush attachment to remove any uneven texture on the back. It should be nice and flat to assure good adhesion later. Paint the plaster however you like, using acrylic paint. Use a paper towel to dab off any excess paint.

Prepare metal backplate

Cut a piece of aged metal to accommodate the bird casting no wider than the width of the belt. Hammer and file the piece of metal. Use gel medium to adhere a piece of book text to the metal. Cut a scrap of etched metal. Attach the scrap to the aged metal by drilling two corresponding holes in each piece and setting eyelets or rivets into the holes.

Flatten eyelets

Place the metal facedown on the steel block and hammer the eyelets or rivets flat, from the front and the back.

Drill for attachment

Drill a ¹⁄₁₆" (2mm) hole in each of the four corners of the aged metal piece.

Attach bird head

Glue the bird to the front of the metal with clear caulk.

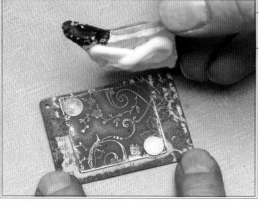

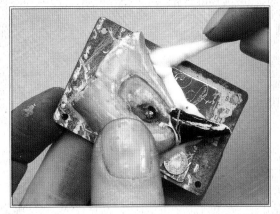

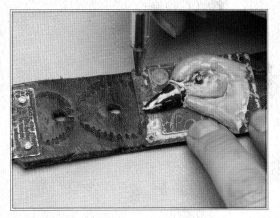

step **17** **Clean up excess caulk**

Take a cotton swab to work the ooze around the
bird edge to seal everything in and to clean it up.
Once the caulk has cured, give the whole piece a
coat or two of spray sealer.

step **18** **Mark metal for attachment**

Center the piece on the leather and,
with a pen, mark where the four corner
holes are.

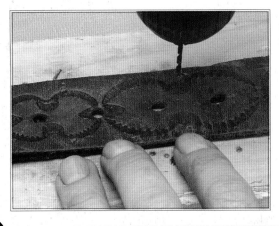

step **19** **Drill leather**

Drill a hole at each mark. (Note: Vintage leather
can often be fragile so be sure you are not too
close to the edge.)

step **20** **Attach bird to leather**

Wrap the end of a length of copper
wire through one hole on the leather
and then thread the metal piece on.

step **21** **Finish the closure**

Wrap the wire around the wrap some
more, then trim off the excess. Repeat
for the other three corners to completely
attach the piece to the leather. To wear
the cuff, have someone help you tie the
two ends together with a silk ribbon.

Paris, 6 mai 1934

CARTE POSTALE

CERTAINS PAYS ÉTRANGERS N'ACCEPTENT PAS LA CORRESPONDANCE DE CE COTÉ (se renseigner à l

Chère belle-maman,

CORRESPONDANCE ADRESSE

BLAZE BONDING

NOW THAT YOU HAVE HONED YOUR SKILLS with cold connections, it's time to add a little heat. Be a bit more adventurous and add to your arsenal of skills to draw upon. Some of the objects you have unearthed up to this point may best be used when slightly altered with exposure to the flame of a torch. Be fearless, yet cautious, in your friendship with this invaluable tool. It can make the impossible possible. A little melted metal or fire patina may be just what you need to create a richly textured piece of jewelry.

Though the projects in this section are as varied as the found objects you will incorporate into your own work, they all share the torch as a valuable tool. For some, it is the primary instrument of excavation and definition. For others, it is the tool to manipulate metal and wire into new form.

Secure the tent flaps and be sure to work upwind of the local village—fresh air and practice are essential for becoming seasoned with the torch and all it has to offer.

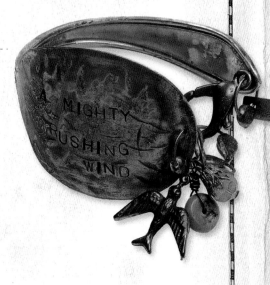

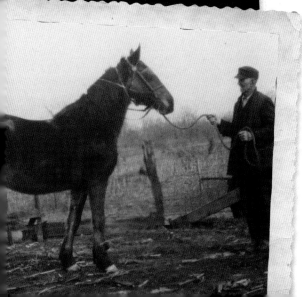

ROOTED CUFF

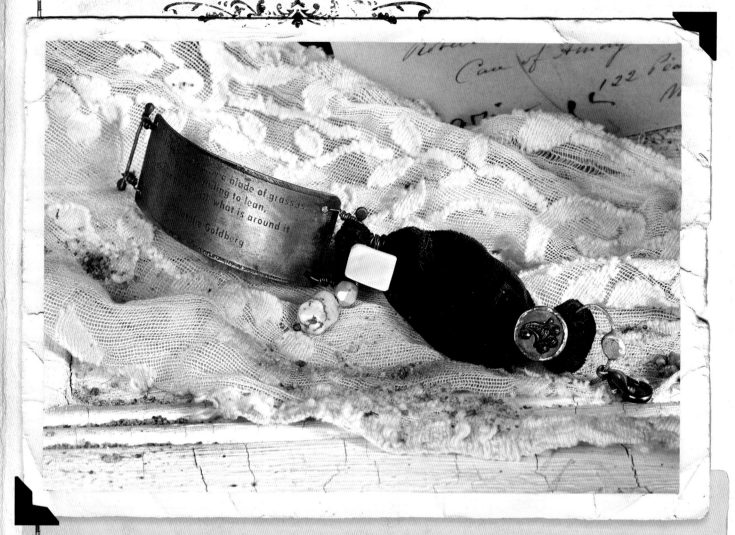

Day 145

SO MANY DAYS AWAY FROM HOME. Each offers a different perspective on the idea of living in transition. I find myself feeling as though the comforts of home are not defined by a spot on the map but by the simple things—walls and floors and a garden. As I picked up a torn scrap of velvet today, from the step outside a company store, I was reminded that the foolishness of youth had me convinced at one time that building an estate was crucial for one's posterity. While it's noble to root oneself in the acquisition of worldly luxuries, it is not as much my priority these days. The zeal I have for this work nurtures a certain spirit of acceptance for the rugged life and I have found a sweet contentment in rooting myself in transition.

I have determined that for me to be rooted in a home, whether of the mind or of the body, I must be willing to bend to the will of the elements and the taunting of time—always waiting and working with no guarantee of reward. My true home is where I am rooted with passion and a youthful appetite to learn all that I can from those here who know this land and all its secrets.

Daypack Essentials

↓

REPURPOSING KIT

BLAZING PACK

copuper wire, 18-gauge

black wire, 24-gauge

brass wire, 20-gauge

laser/photocopy of
reverse-text poem or phrase

acetone polish remover

cotton swab

brass sheet

iron

etchant solution

velvet ribbon

bead charm

shell button

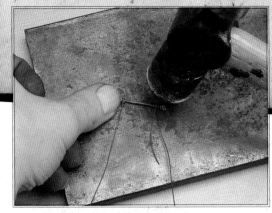

step ❶ Create copper rods

Cut two 2" (5cm) lengths of copper wire and draw
a large bead on each end. Lightly sand the two rods.
Flatten the balls on the rods a bit, using the hammer.

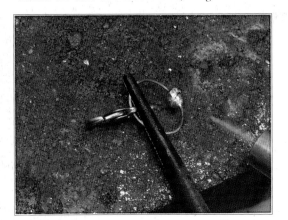

step ❷ Secure wire to rods

Cut four 4" (10cm) lengths of black
wire. With about ½" (13mm) left at
one end, wrap the first piece around
one copper rod, just below the bead,
about three times. Hammer the wire
that's around the rod lightly, to hold
it in place. Repeat with a second
length of black wire by the bead on
the other end. Then, repeat everything
for the other copper rod.

step ❸ Solder ring

Create a brass ring/link that is slightly oval after flattening it a bit, with the ends overlapping slightly.
Thread a lobster clasp onto it. To solder the ring closed, cut a ¼" (6mm) length of solder and set it on
your brick next to the ring. Flux the ring at the overlapping ends and hold this point slightly above
solder with needle nose pliers. Heat both at the same time with the outer flame of the torch (see tip on
page 35) until the solder flows. Touch the wire to the solder and the solder will attach itself to the ring,
securing the overlapping ends together to form a closed ring. This takes practice so don't lose heart if
you don't get it right on the first try.

73

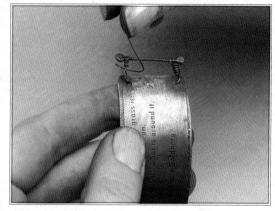

step 4

Etch brass with text

Create a poem or quote (about 1" × 2½" [3cm × 6cm]) on the computer, using white text with a black fill. Use the mirror option to reverse the direction of the type. Print or copy this with a laser printer/copier and then make an acetone transfer to the brass sheet (see page 27). Trim the quote out of the sheet using metal shears, to a finished size of about 1¼" × 2¾" (3cm × 7cm). Etch the brass and blacken it, followed by a light sanding to make the words show up better. Hammer and file the brass, then drill a hole in each of the four corners.

step 5

Curve the brass

Shape the brass into a slight curve so it comfortably fits against your wrist. Using the ends of the wire that you already wrapped around the copper rods, loop through the holes in the brass. Repeat for the other three wires.

step 6

Add the velvet cuff

Cut a 12" (30cm) length of black wire. Cut a piece of velvet ribbon long enough to go around your wrist. Thread the velvet ribbon through one of the rods and scrunch it together so that you can wrap it with wire leaving 1" (3cm) or so of the starting end of the wire sticking out. Wrap the wire a few times tightly to secure the end of the velvet.

step 7

Add a button

Thread a wired dangle or charm that you already made ahead of time onto the wire and then add a button. Continue to wrap the wire around the velvet a couple more times before twisting it with the original end of the wire.

step 8

Finish the closure

Tuck the twisted portion underneath the button. Thread the other end of the ribbon through the oval brass ring/link and trim. Wrap the end of the ribbon with more black wire and thread on another bead. Twist the ends and trim the excess ribbon, then tuck the twisted point under the button.

A-MIGHTY-WIND CUFF

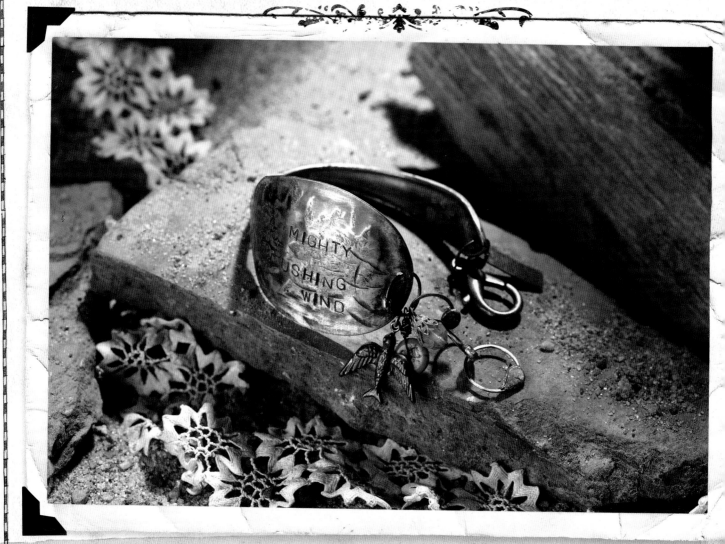

Day 156

WE HAVE MOVED TO A MORE MODERN DIG SITE. Despite the challenge that each move presents, we are becoming more proficient at uprooting and changing locale. We have already settled in here—as much as we settle in anywhere.

The last few days' efforts have unearthed a collection of silver, not coinage or personal adornments, but spoons, and the guide who tends to the animals has taken a fancy to them. Despite our custodial obligation to guard and protect all of our findings, we have shared a few with him. A quiet fellow with a purposeful gait, he has delighted us all with his inventive use of the utensils. He borrowed hair from a generous horse's tail and strung the utensils from the gathering tent's peak. A mighty rushing wind blew through camp last night and we all delighted in the staccato clanking of the makeshift wind chime.

Daypack Essentials

↓

REPURPOSING KIT

BLAZING PACK

decorative bead

teardrop charm

brass sheet scrap

bird charm

black wire, 20-gauge

lobster claw clasp

silver spoon (not gold-plated or stainless)

metal letter stamps

brass wire, 20-gauge

EXHIBIT 156

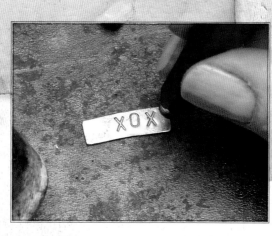

step **1** **Stamp brass charm**

Cut a piece of brass sheet to ¼" × ¾" (6mm × 19mm). Hammer it and file it to remove any burrs. Stamp X O X on one side of the brass.

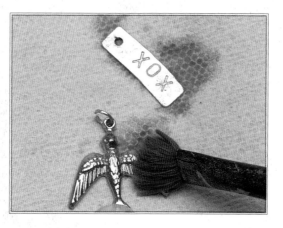

step **2** **Patina the charms**

Use the center punch to mark for a hole at one end of the charm, then drill a hole at the mark. Turn it back over and hammer it again to reclaim its shape. Apply blackening solution to the stamped charm and to the bird charm.

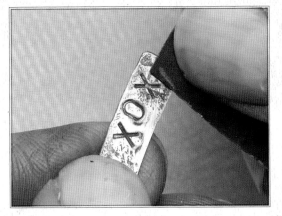

step **3** ## Highlight letters

Wipe off the excess blackening solution after the pieces have set for a bit, then lightly sand the stamped charm.

step **4** ## Anneal spoon

Create a wire wrap for the bead, using black wire (see page 39). Also apply blackening solution to the lobster clasp. All of your charms/dangles should now be ready to assemble. Holding the spoon with pliers, apply heat from the torch until the spoon glows red. It's important to keep your torch moving and not hold it in one place for too long.

step **5** ## Flatten spoon

Annealing the spoon allows you to hammer it flat and shape it much more easily than if you didn't do this (though it still can be done if you have lots of muscle!). With the spoon on a metal block, hammer the bowl flat, working both sides of the spoon.

step **6** ## Stamp phrase onto spoon

Use letter stamps to stamp a phrase onto one side of the spoon.

step **7** ## Drill holes for closure

Use a center punch to mark a spot at each end of the spoon—the handle and the bowl. Drill a hole at the marks in each end.

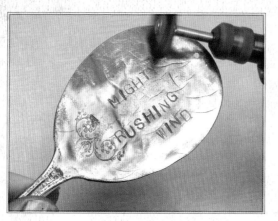

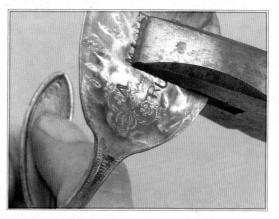

step 8

Patina spoon

Apply blackening solution to the spoon and then wipe off the excess. Use the Dremel and the wire brush attachment to polish the surface of the spoon where it was heated. Polish the front and the back. Sand the spoon lightly, paying special attention to the area where the letters are, to make them stand out and to even out the finish.

step 9

Bend spoon

Using large pliers, begin to form the spoon into the shape you want, working small areas at a time. Work it until it is a shape that is comfortable to get on and off your wrist, leaving a 1"–2" (3cm–5cm) gap between the ends of the spoon.

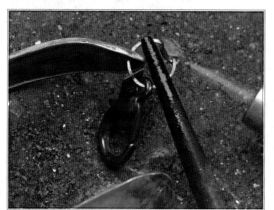

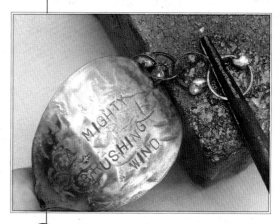

step 10

Create links for closure

Create four small, ½" (13mm) brass ring/links (see page 73) and one large, ¾" (19mm) ring/link. Flatten them all before you solder them. Begin with one small link and thread it onto the handle end of the spoon. Also thread the stamped charm and the clasp onto it. Then, snip off a tiny bit of solder and place it on a brick. Hold the spoon with pliers in one hand against the solder on the brick and torch it to melt the solder. Take a second small ring/link and solder it to the bowl end of the spoon.

step 11

Add links

Solder the other two small ring/links to the previous one, one at a time and then finally, the larger ring/link.

step 12

Finish with charms

Lightly hammer each of the solder joints. Wash the bracelet in soap and water to remove all of the flux. Create a wire wrap from black wire for the bead and add it to the ring/link on the handle end of the spoon. Also, connect the bird charm and the teardrop charm to the same ring/link with jump rings.

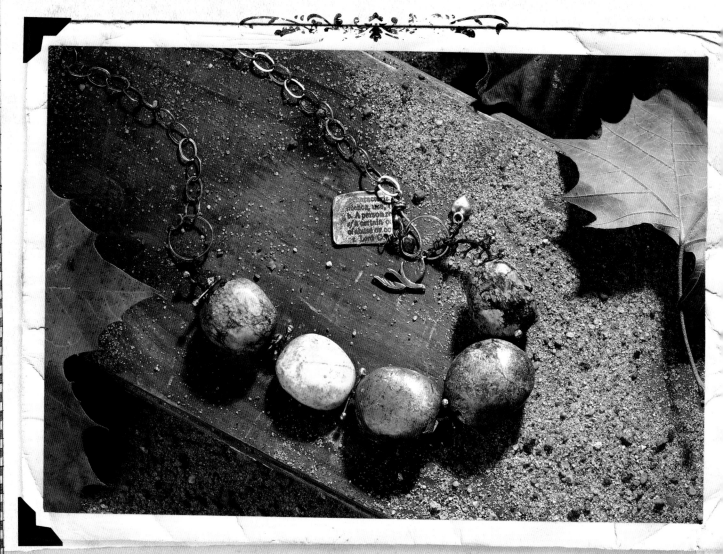

Day 172

THE HOMES IN THIS AREA are not so different from those at some of the more primitive sites. The inhabitants were resourceful and used what the land had to offer to build up their structures. Sound and solid, they survived many years against harsh elements and the daily activity of their inhabitants.

Most of the structures are of stone and wood. As we began to expose the walls of a particular dwelling, we did not know (nor did we particularly care), at first, what kind of stone was used to form the walls. It wasn't until a brisk but aggressive spring rain washed the caked dirt off the stone that we saw the serpentine waves of vivid chartreuse marbleized with rich browns and blacks. What a castle indeed, it seemed to me, to have walls of such grandeur. I knew better than to think that those were the thoughts of the builder, though, as I took note of the home's humble size and makeshift stick rafters.

When one needed shelter in this region, industrious and unpretentious, he looked to the land and what it had to offer for material, not assessing its value and beauty, but its strength and durability.

Daypack Essentials

↓

REPURPOSING KIT

BLAZING PACK

sterling silver wire, 18-gauge

brass wire, 20-gauge

waxed linen thread

stone beads (about 30mm), 5

silver chain, 8¹/₂" (22cm)

bird charm

previously etched metal charm, hole in corner

metal heart charms, 2

black wire, 24-gauge

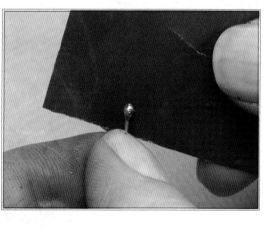

step **1** ## Create wire "sticks"

Cut ten pieces of 1½" (4cm) sterling wire. Using a torch, draw a bead on both ends of each piece.

step **2** ## Brighten "sticks"

Sand the ball ends a bit just to brighten them up.

80

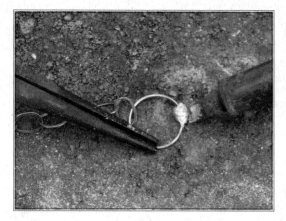

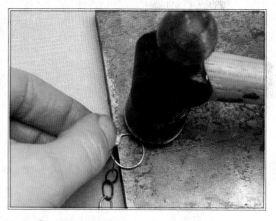

step **3** ## Add chain to link

Create two ring links with the brass wire (do not connect them to each other). Thread one end of the chain onto one of the links and solder it shut.

step **4** ## Flatten links

Hammer the ring/link that was just soldered, keeping the chain off the side of the block as you hammer. Solder the other ring/link (unattached to anything) and hammer it as well.

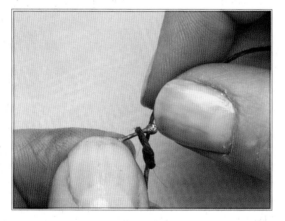

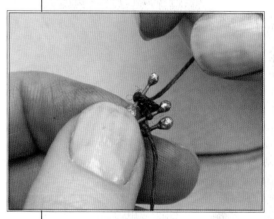

step **5** ## Tie linen to "sticks"

Brush blackening solution onto both rings and wipe off the excess. Cut an 18" (46cm) length of waxed linen. Then, 2" (5cm) from one end, tie on one of the wire sticks.

step **6** ## Add more sticks

Tie on two more little sticks as close as you can comfortably get them. Tighten the knots securely.

step **7** ## Add stone

Thread on a stone bead and then tie on another stick.

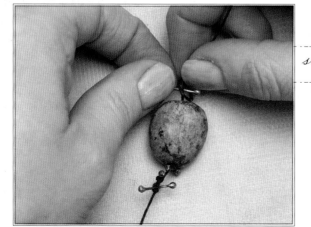

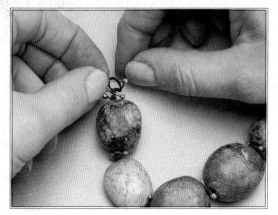

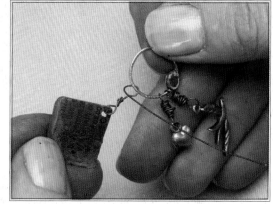

step 8 Add remaining sticks/stones

Repeat this for three more stones and sticks.
Before adding the final stone, thread on one
heart charm. Add the final stone and then
tie on three more sticks like you did at the
beginning of the strand.

step 9 Add charms

Using black wire, create a wire wrap for
the two remaining charms and the etched
metal piece and add them to the soldered
brass ring that does not have the chain
added to it.

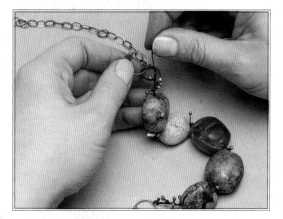

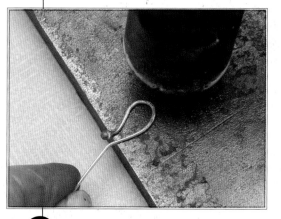

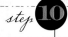

step 10 Connect ends

Tie the ring with the charms onto one end of the
waxed linen with several knots. Tie the other ring
with the chain onto the other end of the linen.
Trim the excess linen slightly above the knot.

step 11 Create hook closure

Cut a 3½" (9cm) piece of silver wire and
draw a bead onto one end of it. Sand it
up a bit. Bend the bead end into a small
hook and hammer the hook portion
lightly with a hammer.

step 12 Connect hook to chain

After forming the hook, create a loop
with round nose pliers on the wire just
below the hook and thread the end
of the chain onto it. Wrap the excess
around the base of the loop. Apply
blackening solution to the hook, wipe
off the excess and you're good to go!

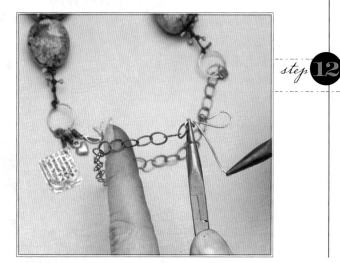

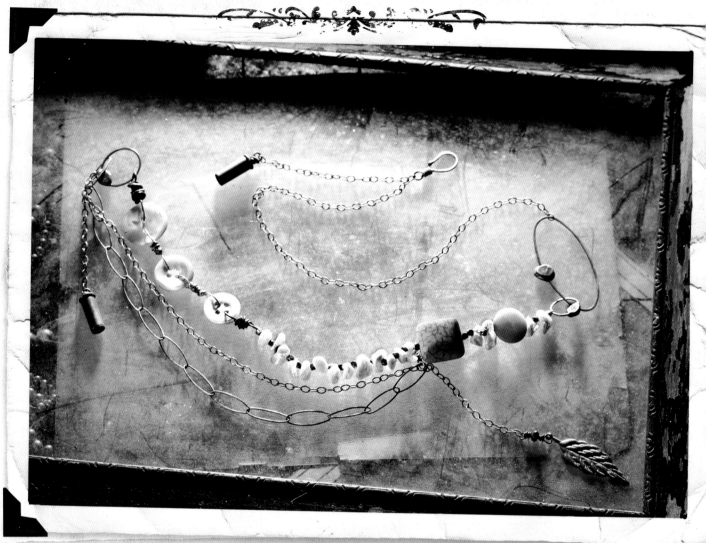

Day 200

SO MANY DAYS ON THE EXPEDITION and none have been as trying as these past few. Our site is at the mouth of a deep canyon and we have been battered by winds that don't seem to let up. Just when I think I can rest in calm, quiet air, a taunting gust turns up the tent flaps, yanks the clothing from the line, and knocks over the tables, cackling and laughing at us grasping at our hats. It's impossible to work in these conditions since with every bit of dirt removed, twice as much is deposited.

A woman came to camp from deep in the canyon. A disheveled crone with twisted garb and tangled jewelry, she offered her land as a new location for us. Though we must stay camped at the site, I decided to follow her back to her home to see what kind of life one would live in such a deep, narrow gorge. I was surprised by the fact that not far into the canyon the winds were much less erratic. She stopped and looked down at her attire and began to disentangle and neaten what her travels and the wind had whipped around. I laughed at my initial assumption of her, thinking that she was just the disheveled sort, and suddenly found it quite enchanting. It's amusing what artistry even this wind can concoct.

REPURPOSING KIT

BLAZING PACK

brass wire, 20-gauge

various styles chain, 13", 10" (33cm, 25cm), 2ea.

larger link chain, 9" (23cm)

shell buttons

sterling silver wire, 24-gauge

beading wire and crimping beads

miscellaneous beads

bullet casings, 2

leaf charm

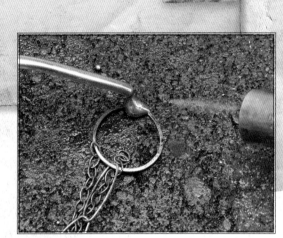

step **1**

Connect chains to soldered link

Create a ring/link (approx. ½" [13mm]) out of brass wire and hammer it. Thread on the 10" (25cm) length of chain and the large 9" (23cm) length of chain, onto the ring and solder it shut.

step **2**

Start button link segment

Create a length of three linked buttons by wrapping them together with 24-gauge silver wire.

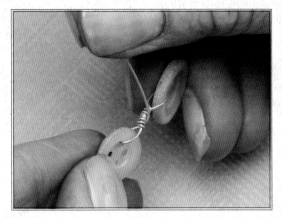

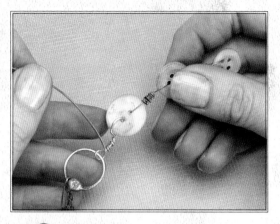

step **3**

Connect buttons

Wrap the excess short end around the wire, just at the edge of the button, but don't wrap so tightly that the button can't move freely. Thread the long end through a hole in the second button and wrap the excess around the wrap between the two buttons.

step **4**

Connect buttons to link

Connect a third button in the same way. Create a bend in a 5" (13cm) length of brass wire and thread on the third button of the segment. Create another loop and connect it to the link from step 1.

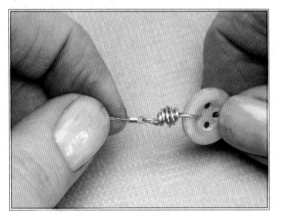

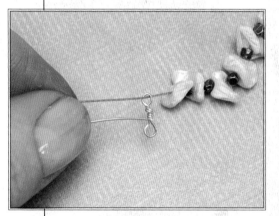

step **5**

Connect beading wire

Cut a second 5" (13cm) piece of brass wire. On the first button of the three button segment, create a loop on the brass wire and connect to the button. Create another loop on the other end of the brass wire but do not thread anything onto it. Cut a 7" (18cm) length of beading wire. On one end, loop the wire through the empty brass loop and then crimp on a crimp bead.

step **6**

Beading wire

Thread 4" (10cm) worth of miscellaneous beads onto the beading wire. (I used tumbled shell beads, a vintage shell button and small metal beads.) Create a silver wire wrapping (with a loop on each end) and thread it onto the wire.

step **7**

Connect chain and beaded section

Before you close the second loop on the silver wire wrapping, thread on the other end of the large 9" (23cm) chain and also the 10" (25cm) chain. (Thread the 10" [25cm] chain, onto the wrapping 2" (5cm) from its end.) Wrap the excess wire around the base of the loop.

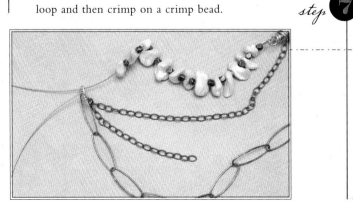

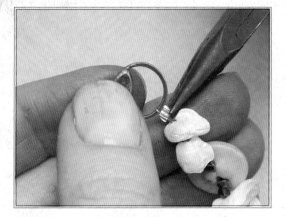

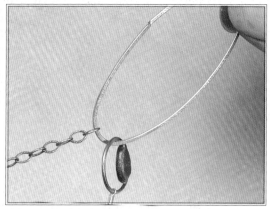

step **8** **Finish beaded segment**

Now, thread two additional inches (5cm) worth of beads onto the beading wire starting with a large focal point bead. Create another link just like the one in step 1. Thread a crimp bead onto the beading wire and then link and loop the beading wire back through the crimp bead. Crimp securely.

step **9** **Add large link**

Create a large oblong brass link and hammer it a bit to hold its shape. Thread on the link that is connected to the beads, as well as the 13" (33cm) remaining length of chain.

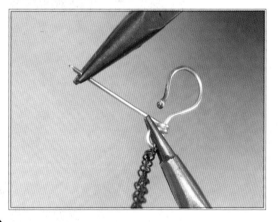

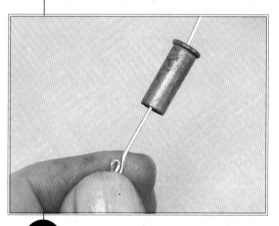

step **10** **Add hook**

Solder the oblong link closed. Cut a 3½" (9cm) length of silver wire and draw a bead on the end of it. Create a hook (see page 82) on the bead end and a loop on the other end. Thread the loop end through a section of the 13" (33cm) chain to make the necklace the size you wish. Cut off any excess chain. Wrap the excess wire around the base of the loop.

step **11** **Create bullet-casing charms**

Drill a hole in the top of the bullet casing. Cut a 3" (8cm) length of brass wire, making a loop at one end and threading the other end through the hole going up through the inside of the casing to hide the loop.

step **12** **Add charms**

Create a loop at the top of the casing and thread that end onto the end of one of the chain ends. Repeat for the other casing. To the ends of the lengths of chain that dangle down, you will now add a charm. Create a wire wrap for the leaf charm and add that to the final dangle of chain.

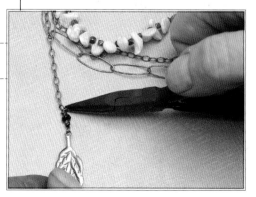

ENCASED-STONE RING

Day 2-13

THE SOIL AT THIS DIG IS MUCH LESS COMPACTED than the previous site. It gives way to our prodding and gouging more readily and in just one day we uncover more than what used to take us nearly a week to unearth. In our comfort and ease, we can be a bit hasty and today one of the team almost cast aside a small treasure.

A sizeable stone, green and veined, was encased in a silver-hued metal and appeared to have once been attached to something else. We have not yet determined the origin of the stone, but are certain that it was part of some cherished article. Lovely, simple and earthy, I roll the stone around in my hand and imagine it my own adornment. Protectively bound up as if a repair was intended before it was buried, I am curious as to what prevented the repair. Was it a lack of tools or skill? Certainly there were metalsmiths of sorts in the colony of the time that could have put the stone back in its place of honor. Perhaps it was set aside with the intention that the repair would be made when the owner wasn't so occupied with the daily task of survival.

Daypack Essentials

↓

REPURPOSING KIT
BLAZING PACK

adhesive-backed
copper sheet

stone or large bead

copper tape, 1/2" (13mm)

bone folder or other
burnishing tool

nickel sheet

copper wire, 24-gauge

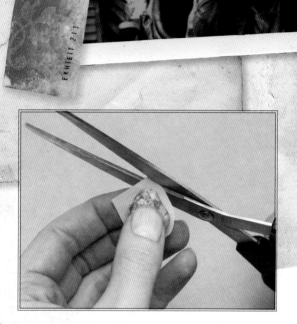

step 1

Cut copper sheet

Leaving the backing on, cut a piece of the
copper sheet to about ¼" (6mm) larger than
your stone.

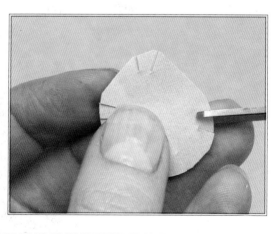

step 2

Notch sheet

Cut a series of small slits around the perimeter.

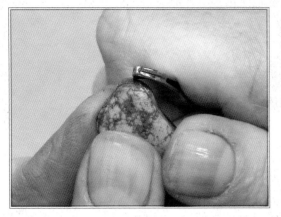

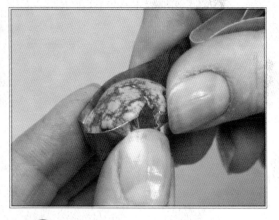

Adhere sheet to stone

Wash your stone (or stone bead) with soap and water. Dry well. Adhere the sheet to the back of the stone and then burnish the tape really well all the way around.

Add copper tape

Apply a piece of tape slightly higher around the perimeter and burnish it well too. This will create a more finished edge to the copper adhesive on the top of the stone.

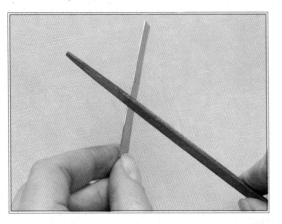

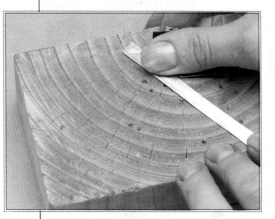

Cut ring band

Cut a strip from the nickel sheet that is ¼" × 2" (6mm × 5cm). Hammer the metal and then file off any burrs.

Create matte finish

Sand the piece lengthwise to create a brushed-silver look.

Tin stone

Gently curve the metal around a dowel, adjust the ring to the size you want and trim it. There should be a $^1/_{16}$" (2mm) gap where the ends meet. Clamp the stone in a pair of needle nose pliers to solder. Heat up your soldering iron and apply flux to the copper sheet on the stone. Pick up a bit of solder with the iron and begin tinning the stone (spreading solder over the surface). Build up the solder as thick as you can to create a strong enclosure holding the stone in securely.

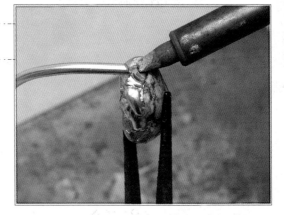

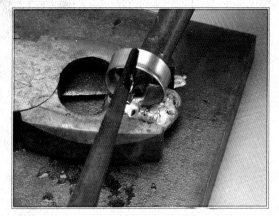

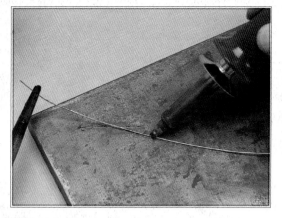

Add ring band

When the stone is completely soldered, apply flux to the portion of the band with the gap and to the back of the stone. Using pliers, position the band to the back of the stone. Pick up some solder with the iron and touch it to the fluxed spot. Hold until it sinks into the solder, then steady while the solder cures.

Tin wire for "cage"

Cut a 6" (15cm) length of copper wire. If your wire is oxidized or blackened, you will need to polish it first with sandpaper to clean it, or it won't accept any solder. Apply flux to a section of wire and then tin it with solder. Work in sections until the entire piece is tinned.

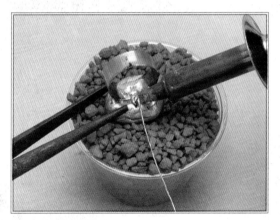

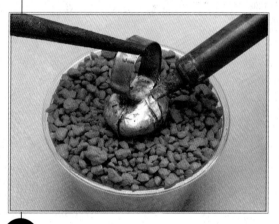

Attach wire

Nestle the ring in a bowl of sand or rice to make it easier to work on. Create a tiny crook at one end of the wire, and solder it to the back of the ring, just below the band.

Finish attaching wire

Wrap the wire over the top of the stone and back under. Solder it where it meets the back again. Wrap it around the stone again in the opposite direction and solder in the back. Repeat for as many times as you wish to wrap it around the stone.

Polish soldered areas

Apply blackening solution to all of the soldered areas and the band. Let it sit for a minute and then wipe off the excess. Polish it back just a bit, using the Dremel tool and the wire brush attachment.

LOST & FOUND NECKLACE

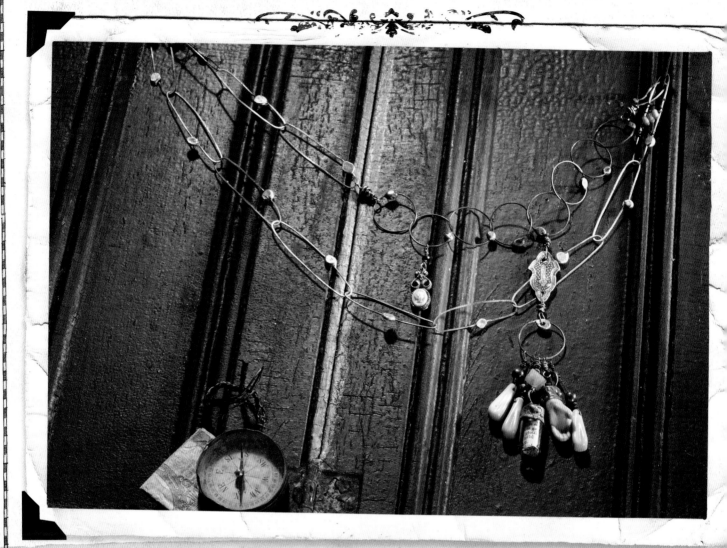

Day 222

TODAY THE EARTH READILY GAVE WAY to our efforts revealing bits and pieces of a woman's collection of jewelry. Surprisingly, the delicacy of the pieces was not compromised by years of dark entombment. A hand-hewn chain held a small, carved bone flower encased in brass, long blue beads, a porcelain doll foot and a tiny apothecary bottle. Obviously not original to the chain, the items must have been cherished to be worn this way.

I imagined this woman to have been a mother, keeping treasures of her life and children close to her heart. Perhaps they all lived long and healthy lives and cared for her when she was old and ailing. Perhaps not. Painting a picture from the past, my mind mulls over the life of this woman. I sit still under the shade of the canopy, watching the birds frolic on the ground. Could she have rested in this very place watching her little ones?

Daypack Essentials

↓

REPURPOSING KIT

BLAZING PACK

brass wire, 20-gauge	glass vintage beads, 3
1" (3cm) dowel	square bead
sterling silver wire, 18-gauge	small beads, 2
sterling silver wire, 24-gauge	vintage drop-cameo
black wire, 24-gauge	bone beads, 6
tiny glass vial	etched nickel keyhole
book text	freshwater pearls, 3
	porcelain doll hand

EXHIBIT 200

step ① Create large links

Cut twelve 5" (13cm) lengths of brass wire. Form each piece into an oblong ring/link, with the ends overlapping about ⅛" (3mm). Hammer the shapes flat. Solder the links individually, connecting each new one to the one just soldered to create a chain.

step ② Create smaller links

Cut approximately 24" (61cm) of brass wire. Wrap it around a 1" (3cm) dowel to create a "spring" (see photo, step 8, page 98). Remove from the dowel and, with wire cutters, snip in the same spot on each round to create individual links. Hammer the rings flat and solder eight of them together connecting them to create a chain.

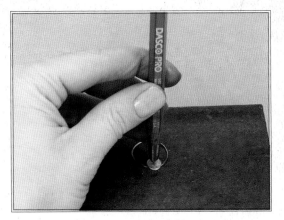

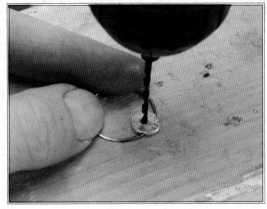

step ③ **Create single link**

Solder the final link together by itself, with a large enough dollop of solder to hammer and create a hole in. Use a center punch to mark the center of the solder dot.

step ④ **Drill link**

Drill a hole at the mark.

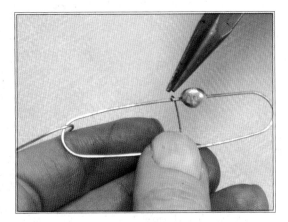

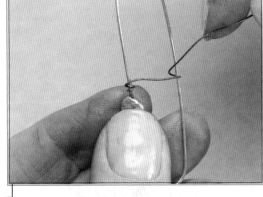

step ⑤ **Add wire to link**

Cut about a 6" (15cm) length of black wire. Create a tiny hook at one end and hook it to the end oblong link. Squeeze with needle nose pliers to secure.

step ⑥ **Cross wire to other side of link**

Wrap the wire around the link wire a couple of times, then all the way over the link to the other side.

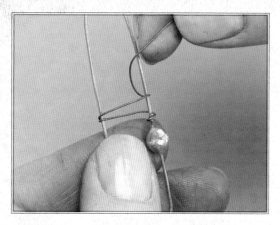

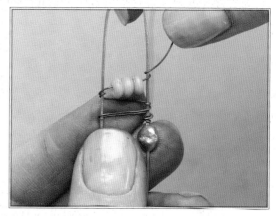

step

Return wire to starting side

Secure the wire there by wrapping it around the link wire.

step ⑧

Add beads to the wire

Wrap the wire back across the link to the other side, wrap it around the wire, thread on three beads, wrap it back across the link to the other side and wrap it around the wire to secure it. Make a few more passes back and forth across the link and secure the end with pliers after trimming the excess. Repeat this process for the third oblong link from the other end of the chain.

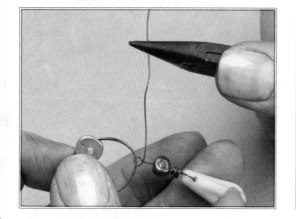

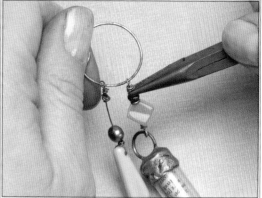

step ⑨

Add beads to lone link

Using the black wire, create wire wraps for the three vintage glass beads and secure them to the single ring/link.

step ⑩

Add capped vial

Put a small snippet of paper in a tiny glass vial. To create a soldered cap on the vial, cover the opening with a couple of layers of sheet copper and then wrap the lip with copper tape in the same way you created the encased stone ring (see page 89). After you have soldered the coppered area, solder a jump ring to the top. Add a wire loop wrapping to the jump ring, connecting the other end to the soldered brass ring.

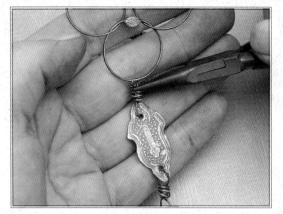

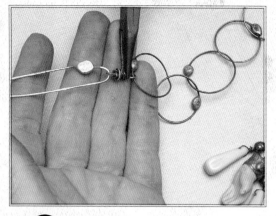

step **11**

Add etched keyhole piece

Create a rubber-stamped etched keyhole on sheet nickel (see pages 18 and 19) and cut it out. Hammer, file and sand it, then drill two holes in it, one at the top and one at the bottom. Cut a 4" (10cm) length of the 24-gauge silver wire, loop it in the bottom hole of the keyhole piece, then wrap it to connect it to the single ring with the dangles. Cut another 4" (10cm) length of wire, loop it through the top hole of the keyhole piece, then wrap the other end of the wire through the fourth-from-the-end link in the round link chain. Wrap the rest of the wire around itself to finish the connection.

step **12**

Connect soldered chains

Cut a 4" (10cm) length of 24-gauge silver wire and wire wrap one end of the oblong chain to the circular chain.

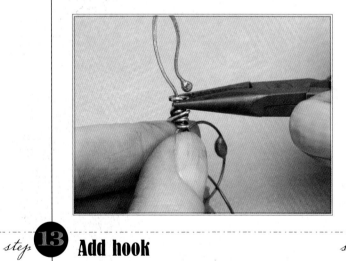

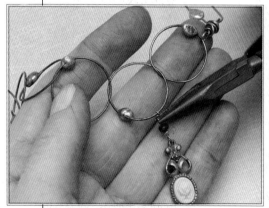

step **13**

Add hook

Create a hook out of the 18-gauge sterling wire and connect it to the other end of the circle chain.

step **14**

Add final charm

Finally, attach the drop-cameo to the second ring/link from the end with a wire wrapping.

FLOTSAM NECKLACE

Day 236

WE HAVE BEEN WORKING TIRELESSLY FOR MONTHS and determined that a few days of rest and play were long overdue. We packed the mules with enough food and supplies to keep us entertained for a day or two. Donning our lightest clothing—and spirits—we set out for the water's edge.

After only a few hours travel we arrived at the beach, many of us removing our shoes before we fully crossed the edge of the tree line and stepped out into the open sky. Months encumbered by boots and stockings had us pining for the feel of the moist sand and water between our toes. It is impossible to think too much of work when the sea wind whispers in your ear, calling you to rest and bask in the sunshine. The flotsam deposited by the waves left an undulating pattern on the surface of sticks, worn smooth by the water and sand. All lay in the same direction, lined up like little soldiers, waiting to be recaptured by the thirsty return of the water. Seashell after seashell intermingled incognito, hoping to rejoin the water as well. I gathered a few treasures into my pocket and enjoyed the rest of our time at the water, occasionally fondling the little gifts from the sea.

Daypack Essentials

↓

REPURPOSING KIT

BLAZING PACK

sea shell

jump ring

clear caulk

brass wire, 20-gauge

dowel or large marker to make links

vintage necklace that you like, approx. 18" (46cm)

sterling silver chain, two 4" (10cm) sections

step **1** ## Tape shell

Wrap the tip of the shell with a small bit of copper tape.

step **2** ## Add solder

Burnish the tape to the shell. Apply flux to the copper and then apply solder, moving it around with the iron until the copper is covered.

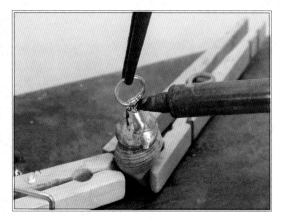

step **3** ## Add jump ring

Prop the shell up with a clothespin and solder on a jump ring.

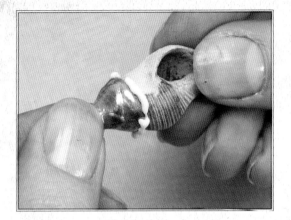

Glue solder cap

Apply blackening solution to the cap and wipe off the excess with a paper towel. Polish it with a Dremel tool and a wire brush attachment. Pull the solder cap off of the shell and then glue it back onto the shell, using clear caulk. Wipe off any caulk that oozes out with a paper towel. Let dry.

Create solder stick

To create what I call "solder sticks," cut a 2" (5cm) length of solder and manipulate it with the iron to create a twig-like shape. Work on a brick and make sure that the ends remain wide enough to support a drilled hole. For this project, I created a total of four sticks.

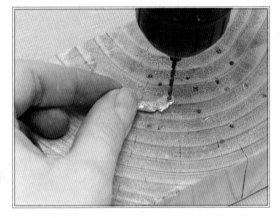

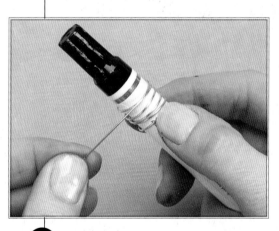

Add texture to stick

Use a triangular metal file to create additional texture on the twigs and to remove any sharp areas of solder. You can also use the center punch or a nail to create additional texture. Use a center punch to mark two holes for drilling, one at each end of each twig. Create the holes, using the drill.

Wrap wire for rings

Apply blackening solution to the twigs and wipe off the excess with a paper towel. Polish them with a Dremel tool and a wire brush attachment. Set the twigs aside. Roll a 12" (30cm) length of brass wire around a large dowel or something else round, such as a paint pen.

Cut individual rings

Remove the coil from the marker and use tin snips to cut the coil into rings. You will want at least seven. I made five large and two that are slightly smaller.

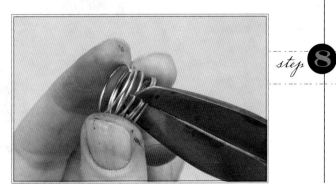

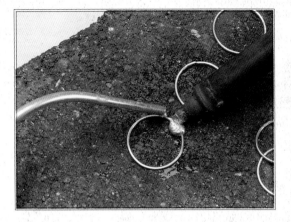

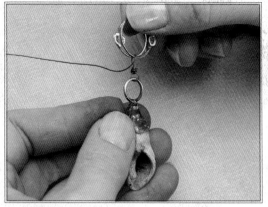

Solder links

Adjust the first ring/link so that the ends meet.
Apply flux and solder the ends together, using the
soldering iron. Repeat and solder all of the brass links
individually (not connecting them to each other).

Flatten and patina links

Next, hammer the links flat and then apply
blackening solution. Wipe off the excess solution,
then sand the links, using sandpaper, to bring
back a bit of their color. Cut a 4" (10cm) length
of black wire and about 1½" (4cm) from one
end, create a small loop, using round nose pliers.
Thread the shell onto the loop and wrap the
short end around the base of the loop. Create a
second loop above the wrap and thread on two
of the brass rings at the same time. Wrap the rest
of the wire back around the wrapping.

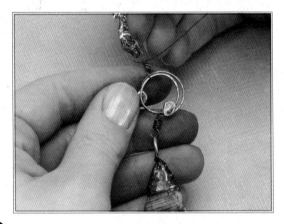

Connect links to first stick

Cut a new 4" (10cm) length of black wire and
create a loop about 1½" (4cm) from one end.
Thread the two brass rings onto the loop and
wrap the wire back around itself to close the loop.
Create another slightly larger loop just above the
wrapping and thread through one of the holes
on a solder stick. Wrap the rest of the wire back
around itself to finish the wrapping.

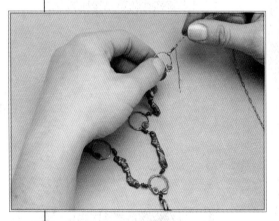

Connect rest of links and sticks

Create another wire wrap to connect
the other end of the twig to a single
brass ring, then another wrap to
connect that ring to a second solder
stick, and then finally to a brass
ring. Repeat for the other side of the
shell. Now, create a wire wrap for
each ending brass ring and wrap them
to either end of each piece of the
silver chain.

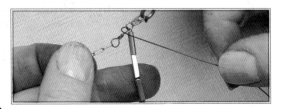

Add chain

Finally, wire wrap the two sections of silver chain to the
two jump rings on either side of your vintage necklace.

PORTRAIT PENDANT

Day 249

ANOTHER TEAM OF ARCHAEOLOGISTS is passing through the area. With their sites set on vastly different finds then ours, there is no sense of competition and we are having a grand time with them as guests in our camp. They are only a few weeks into their expedition and their eyes are fresh and bodies energetic. We've exchanged adventures of other lands and findings. It's good to hear that we are not the only ones who love this work as much as we do and that this life of movement and uncertain reward is a reward in itself.

One of the members of the other company has a camera for taking photographs. It's a delight to see images of the places they have traveled, the people they have met, and the things they have seen. Much to our excitement, the owner of the camera offered to take our photograph. It took a few minutes to convince the guides that the strange contraption pointing at them was not dangerous and that it would capture their likeness forever. They still didn't seem to understand but indulged our fancy anyway, sitting proud and staring indifferently at the camera. I'm glad to know I can see the faces of the people I've grown so fond of even after our time together is over.

EXHIBIT 249

↓

REPURPOSING KIT

BLAZING PACK

copper pipe, ³/₄" (19mm) needle

pipe cutter burnt umber
 acrylic paint
brass sheet

photo or other image
(not an inkjet copy)

two-part epoxy

silk ribbon

jump ring

Gives a ri
While m
CROWN
ladies

step **1** **Cut pipe**

With a pipe cutter, cut a section of copper pipe
to create a ¼" (6mm) high ring.

step **2** **Cut brass**

Cut a 1¼" (3cm) square from a piece
of brass sheet.

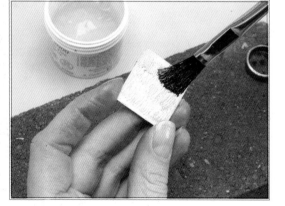

NOTE {to self}

Copper must be sanded and free of any
patina before it is soldered, or the flux/
solder will not stick to it.

step **3** **Prepare to solder**

Hammer the piece flat and file the edges. Apply flux
to the entire surface of one side of the brass.

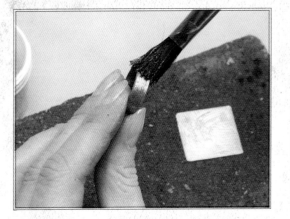

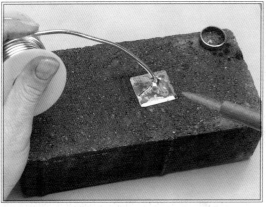

step 4 — Add flux to copper

Coat the outside of the copper ring with flux as well.

step 5 — Add solder to the brass

Heat up the brass with the torch until the solder starts to flow. Keep the larger, outer flame of the torch about 3-4" (8–10cm) away from the brass to prevent heating it up too fast, burning off the flux and not allowing the solder to adhere.

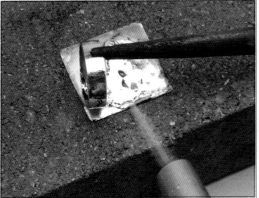

step 6 — Add copper ring

Set the copper onto the solder and reheat until the copper sinks down into the solder. While the solder is still fluid, quickly pick up the copper with pliers, turn it on its side and roll it through the solder.

step 7 — Reheat solder

Set it back down onto the brass toward the bottom of the square. Hold the flame about 3-4" (8–10cm) away from the piece while heating it or else the copper will blacken and not allow the solder to stick. If this happens, let the piece cool, then scrub clean, re-flux and try again. Lightly wave the flame over the whole piece to even out the solder.

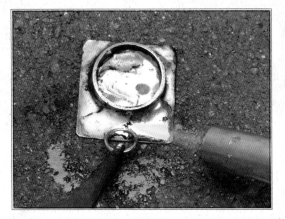

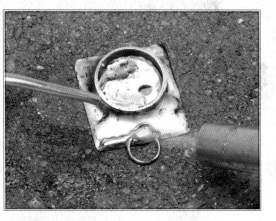

Add jump ring

Add a jump ring to the top of the square, just above the copper ring.

Secure jump ring

Add a little more solder on top of the jump ring, using the torch, to make sure it's secure.

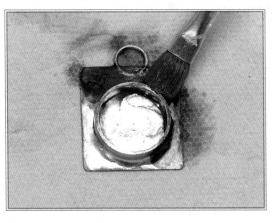

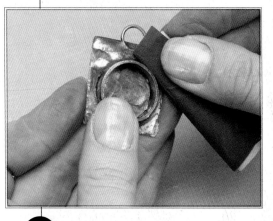

Add patina

Apply blackening solution to the bezel and rub off the excess with a paper towel.

Sand patina off

Lightly sand the bezel to even out the color and provide a bit of texture.

Add your image

Sand the back of the bezel as well, then seal it with a spray sealer. Cut out an image for the bezel and, using gel medium, adhere it to the back of the bezel.

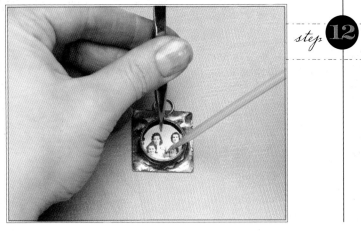

103

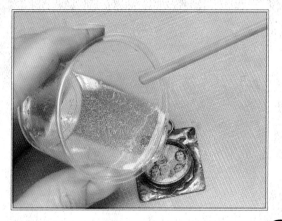

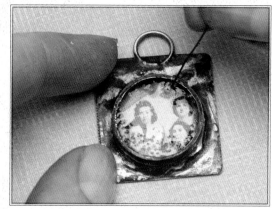

step **13**

Pour resin into bezel

Apply additional gel medium to the top of the image. Mix equal parts of two-part epoxy resin, according to the manufacturer's directions and pour it into the bezel. Pour in enough to get a slight curve at the top of the piece.

step **14**

Add texture to resin

Use a lighter or a match to dislodge any bubbles that rise to the surface. Leave the bezel to cure for a few hours. Before it has cured too hard, use a straight pin to create divots in the surface of the resin. Let it finish curing. If the divots don't stay, wait a little longer and try creating them again.

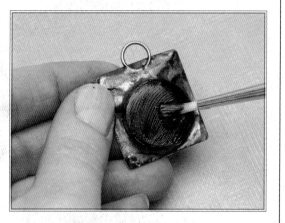

step **15**

Add paint

After the resin has completely cured, brush a bit of burnt umber paint over the surface of the resin. Let it sit for a moment.

step **16**

Wipe bezel

Use a paper towel to wipe the excess paint off, leaving some in the divots.

TIME-CAPSULE RING

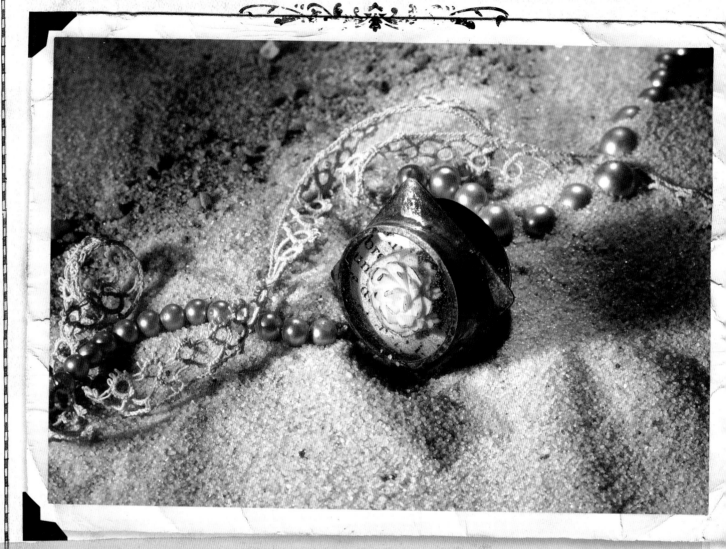

Day 263

OUR GUESTS HAVE DECIDED TO EXTEND THEIR STAY a while to help us in our efforts. I imagine they won't be here much longer than a few weeks and we will certainly appreciate their help in getting us further along in our dig. One of the women from their company is a jolly soul and spends much of her time recounting colorful stories of her life and labors. She keeps me entertained and I've grown fond of working side by side with her.

She told me that on every expedition she "borrows" a find to add to her own collection. She's careful never to choose something of importance or value to the expedition, just a small trinket to serve as a reminder of that particular expedition and preserve it in a time capsule of sorts. With hundreds of expeditions to her credit, she has amassed quite a collection. I imagine sitting in her parlor on a simple settee, sipping tea and listening to her stories while the sun shines through the windows, which act like a prism, sending a thousand shards of light to dance around the room illuminating her memories.

REPURPOSING KIT

BLAZING PACK

brass sheet

copper pipe, ³/₄" (19mm)

decorative paper

found object jewel

two-part epoxy

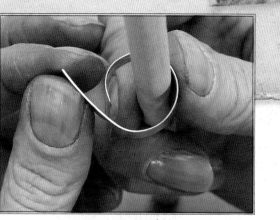

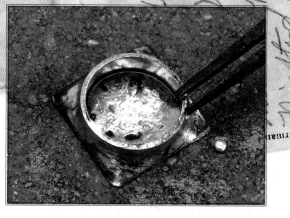

step 1 Cut all metal pieces

Cut a piece of brass 1" (3cm) square and a second strip ¼" × 2½" (6mm × 6cm) for the ring band. Also cut a piece of copper pipe to about ¼" (6mm). Hammer and file both brass pieces. Determine the size the ring needs to be and use the curved surface of a dowel to form the strip into the proper size and shape. Trim the excess brass, leaving about a ¹⁄₁₆" (2mm) gap where the ends come together.

step 2 Solder metal pieces together

Apply flux to the brass square and the copper pipe section and solder them together as for the Bezel Pendant (page 102, steps 5–7), only this time, center the piece of copper pipe in the center of the brass.

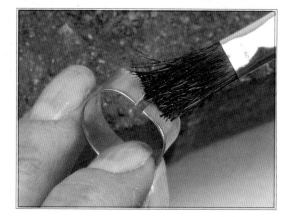

step 3 Add flux to ring band

Turn the piece over and apply flux to the back of the brass and to the portion of the brass band that has the gap.

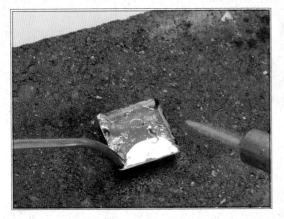

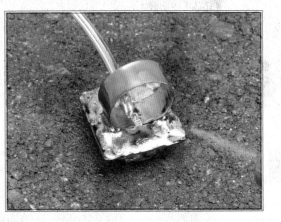

Flood with solder

Flood the back of the brass with solder.

Attach band to bezel

Heat up the band a bit, then set it into the solder, centering it. Heat with the outer part of the torch flame until the ring sinks into the solder. Add a bit more solder to the top of the gap to secure it, then let it cool.

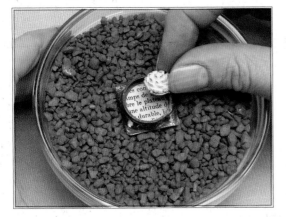

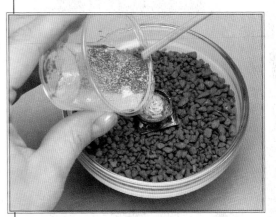

Add found objects

Apply blackening solution to the entire ring. Let sit for a minute, then wipe off the excess. Sand the entire surface to even out color and create a bit of texture.

 Nestle the soldered ring in a bowl filled with sand or rice, making the top of the ring as level as possible. Cut out a piece of decorative paper that is the size of the bezel and adhere it to the inside of the bezel with gel medium. Apply additional gel medium over the top to seal it. Apply a dot of glue to the back of your found object jewel and set it in the ring's bezel. Let the glue set.

Fill bezel with resin

Mix equal parts of two-part epoxy resin according to manufacturer's directions and pour it into the bezel. Pour very slowly, to allow the resin to flow into all of the crevices of your found object. Pour in enough to get a slight curve at the top of the piece. Use a lighter or a match to dislodge the bubbles. Set aside to cure. Check for new bubbles periodically for the first ten minutes or so.

PROOF-OF-LIFE BEZEL

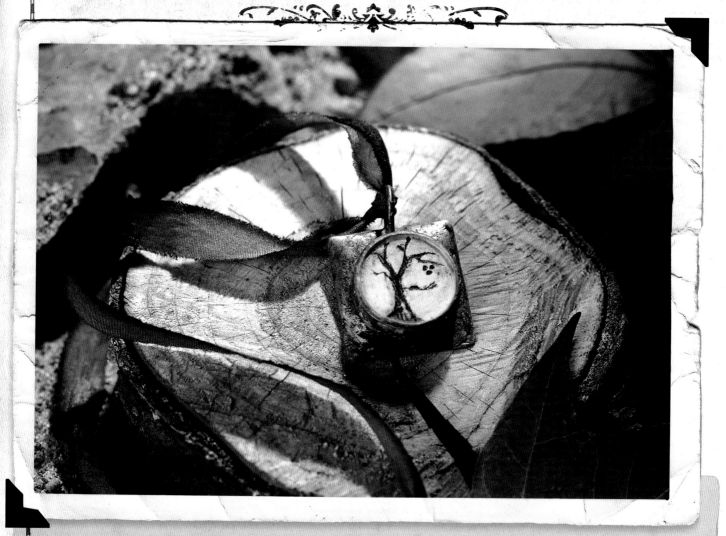

Day 279

WE HAVE BEEN SPOILED WITH SOFT SOIL that gives way easily to our digging. Once we penetrated the crust of the surface, all was easy and we have kept a good pace. This week we hit a vein of limestone and this deposit will certainly hinder our progress.

While chiseling away the stone, we are finding many tree roots that seem to have not known that limestone is harder than the soil. A tiny, fine root finds a crack and works its way in. It grows and fattens and pushes its way through, anchoring itself stronger in the earth. No wind can uproot this hold and I feel a bit invasive exposing these roots to air and sunshine. As we excavate the stone in search of our treasures, the intruding roots are removed revealing a striking carved pattern—proof of the tree's life—bisecting time and the elements to keep a firm hold on its survival.

REPURPOSING KIT
BLAZING PACK

plaster

wood glue

brass and copper bezel
(see pages 102-103)

quilting needle

gel medium

acrylic paint

paintbrush

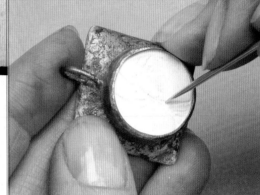

Gives a ri
While m
CROWN
ladies

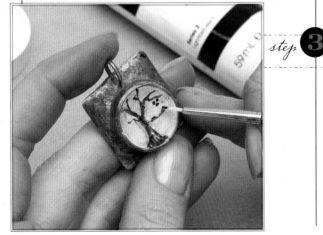

step ① Fill bezel with plaster

Mix up a small amount of plaster, adding about
one part wood glue to three parts plaster. Use
enough water to make the consistency like
a sweet roll glaze. Fill the bezel to about 1/16"
(2mm) below the top of the bezel. Tap out any
bubbles, and dislodge any that don't pop on their
own with a lighter. Set the bezel aside until the
plaster has set.

step ② Carve plaster

Use a quilting needle to carve an image or
design into the surface of the hard plaster.
Here, I am creating a tree.

step ③ Paint carving

After you are happy with your carving, seal the
piece with gel medium. When the gel medium is
dry, you can paint the carved image with acrylic
paint. When the paint is dry, apply several coats
of gel medium, letting it dry between coats.

MOVING-ON BELT

Day 294

OUR GUESTS HAVE MOVED ON. They left this morning and after enjoying their great company for the time that we had it, I'm feeling a bit melancholy. It's interesting how you can know someone your entire life and sometimes feel a stranger to them and someone else might only walk in and out of your life briefly and you feel you have known them forever. These folks were instant friends and we hope to reconnect at a later date, which, in all likelihood, would be years from now.

We helped them gather their supplies and pack their mules for the next leg of their journey. It was bittersweet laughing and poking fun while knowing they would be out of sight within hours. I shared some trinkets from our finds with a man from the group who had most generously offered his knowledge and help in our venture. Buttons I found a few months ago caught my eye and I sent them with him as mementos of our time together. We said our good byes and, with chins up, waved jolly adieus. Good-bye, dear friends. May your journey take you to treasures beyond your expectations.

Daypack Essentials

↓

REPURPOSING KIT

BLAZING PACK

torn fabric strips, long enough to go around your waist plus about 12" (30cm)

ribbon, same length as fabric strips, plus 4" (10cm)

brass sheet

copper wire, 12-gauge (try stripped electrical wire)

vintage buttons, 3

needle and thread

plaster

wood glue

image

pastels

artist brush

gel medium

EXHIBIT 294

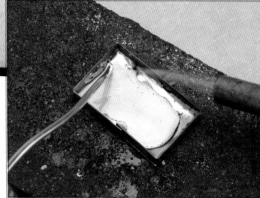

Gives a ri...
While m...
CROWN
ladies

step 1 — Form back and side of bezel

Cut a piece of brass sheet to 1¼" × 2" (3cm × 5cm) and a strip ¼" × 6¾" (6mm × 17cm). Hammer each piece and then begin bending the narrow strip with pliers, to go around the perimeter of the brass rectangle. Use a scribe to mark where you want to bend it next, one corner at a time. Make the frame slightly smaller rather than bigger so that it sits on top of the back sheet.

step 2 — Seal seams

Trim the excess part of the strip, but leave a ⅛" (3mm) overlap. When you have a nice, conforming shape to the sides, apply flux and begin heating the box with a torch. When it is hot enough to start adding solder, begin pooling it at the corners and along the sides to seal the crack along the bottom.

step 3 — Solder overlap

Let cool for a minute. Stand the piece on its side, on the side where the strip overlaps, and solder the seam.

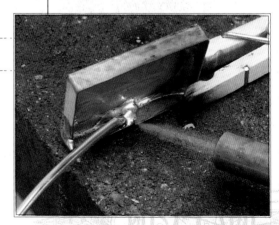

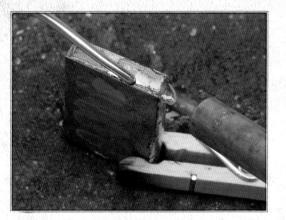

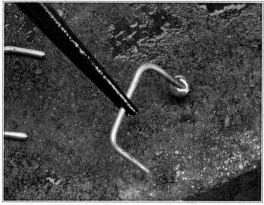

Solder outside of bezel

The only part of this box that will show is the
outside, so that is what will be covered in solder.
Don't worry about covering the complete inside.

Form wire loops

Cut two 2¼" (6cm) lengths of copper
wire. Bend each piece into a 1¼" (3cm)
U-shape. Flux each piece, then pick up
a bit of solder on the ends of each one
by heating up the copper and touching
it to a piece of solder on your brick.

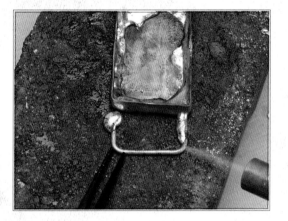

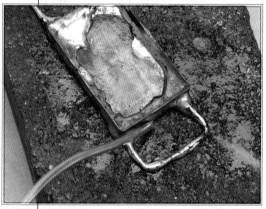

Connect loops

Connect the wires to the box with the torch
and the solder dollops.

Finish loop connection

Coat each of the pieces of wire with
solder, building up the connection a
bit to make the joint even stronger.
Lightly go over the entire piece to
even out any uneven solder chunks.
Set the piece aside to cool.

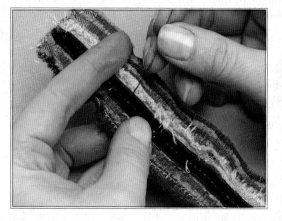

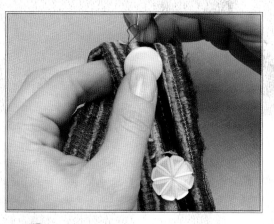

step 8 — Sew belt strip

Next, sew one narrow strip of fabric down the center of a larger strip that is about 1" (3cm) wide, then sew the ribbon on top of that.

step 9 — Add buttons

Starting at about 4" (10cm) from one end of the belt, sew on four vintage buttons (approximately the same size) about 2" (5cm) apart, down the center.

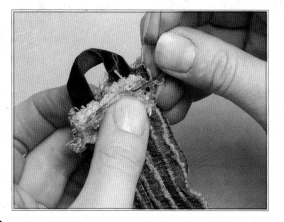

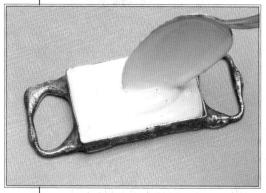

step 10 — Add button loop

On the same end of the strip that you have sewn the buttons on, create a loop with a piece of ribbon. This will loop through the buckle and back to the buttons when the belt is finished.

step 11 — Fill bezel with plaster

When the buckle piece has cooled, wash the flux off with soap and water, then file any rough spots that may still remain. Brush on blackening solution and wipe the excess off with a paper towel. Mix up a small amount of plaster, which includes a bit of wood glue (see page 109). Pour the plaster into the buckle bezel and put it aside to set up.

step 12 — Smooth out plaster

After the plaster has set, lightly sand the surface to make it smooth.

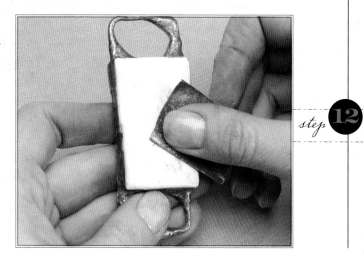

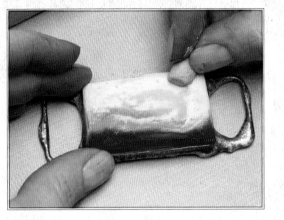

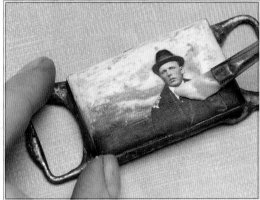

step

Add color

Rub on a background color or two with pastels and work it into the plaster. Add a landscape if you wish, or any other details.

step

Seal color

Seal the pastel with gel medium. (If you work the pastels into the plaster when the plaster is set but still has some moisture to it, then you may not need to use a fixative on the pastels.) Cut out an image and use gel medium to adhere it to the plaster. (Doesn't my great-grandpa look dapper in his Sunday hat here?)

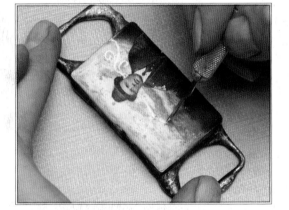

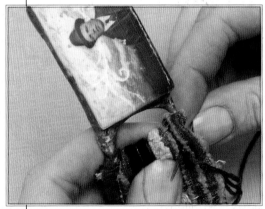

step 15

Carve designs around imagery

Create texture with a craft knife or scribe for added interest. Then, give the plaster a few good coats of polyurethane or other durable sealer.

step 16

Add belt strip

When the sealant on the buckle is dry, thread the raw end of the fabric through the left bar, from the front to the back and then stitch it together. Your belt is now ready to sport around camp!

REMEMBERING PENDANT

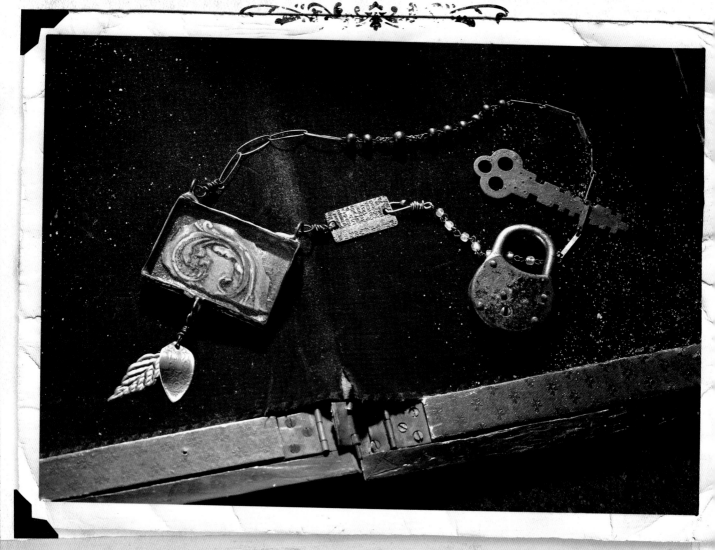

Day 3-15

WE ARE ALMOST AT THE END OF OUR JOURNEY. Our time here has been full of adventure, hard work and laughter. We have a great bounty to take home with us for study and speculation. Our company has proven its efforts fruitful and we all look forward to reacquainting ourselves with our permanent homes. How time has flown! We've been away so long—nigh on a year—yet we are already fancying our next adventure together.

I have been busy sorting and categorizing our finds, packaging them carefully for the arduous journey home. As I look through them, I am reminded of the days each one was unearthed. Like children, it would be impossible to choose a favorite, but I am partial to the small fragments of carved stone we have been perplexed by. Uncertain of their origin or purpose, I am smitten with the delicately carved patterns in the thin and fragile stone. Perhaps I will keep one for myself, my personal memento of this time and my dear friends.

REPURPOSING KIT

BLAZING PACK

brass sheet	oven-dry Sculpey
scribe	rubber stamp
plaster	jump rings
water	etched nickel sheet
spoon	assortment of vintage necklaces/chains
wood block	acrylic paint
wood glue	leaf charms

EXHIBIT 3.15

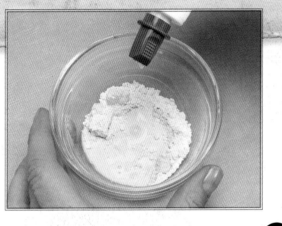

step ❶ Stamp clay

Condition enough clay to accommodate your chosen stamp and then roll it out to about a ¼" (6mm) thickness. Press the stamp firmly into the clay, and carefully pry the stamp off. Set the clay onto a block of wood or something that can be lightly dropped to work out bubbles. Put a small amount of dry plaster mix into a bowl and squeeze some wood glue over the top of it. Also add a bit of water. (See page 109.)

step ❷ Add plaster to stamped clay

Mix the plaster with a spoon. Get the lumps out while it's on the thick side, then add more water until the plaster is the consistency of a sugar glaze. Fill the clay mold with the plaster, adding it over the deep areas first. Lightly drop/tap the block and clay on the table to work the plaster down into the mold, then continue filling the mold. Set aside to cure.

step ❸ Cut bezel form

Cut a 2" × 3" (5cm × 8cm) piece of brass sheet and scribe a line about ¼" (6mm) from the outside on all four sides.

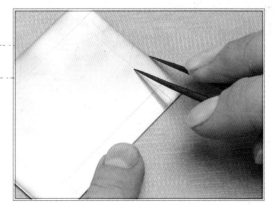

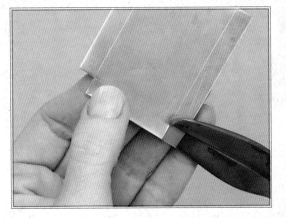

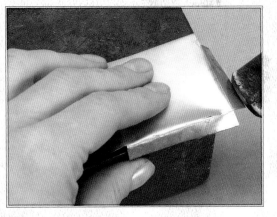

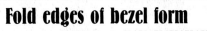

step 4 — Snip out corners

Remove the corners with metal shears.

step 5 — Fold edges of bezel form

Hammer the corners flat. Fold up the sides by first setting a flap over the side of a metal block and hammering it over.

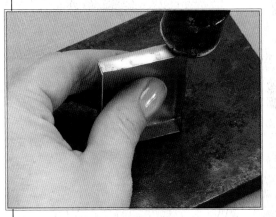

step 6 — Fine-tune folds with pliers

Use the pliers to bend the flaps a bit beyond where they need to be, then ease them back out. This will create a sharper fold.

step 7 — Hammer folds

Lightly hammer the corners to make them meet nicely. (This takes patience and care to get everything just right.)

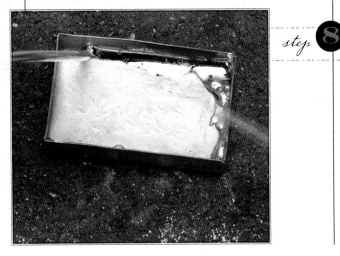

step 8 — Solder seams

Re-hammer the back of the box as well if needed. Use a file to smooth the edges and to remove the sharpness of the corners. Apply flux to the inside of the box, working it into the corners. Heat up the metal with the torch, moving it around to avoid overheating any one area. Start adding solder first to the corners.

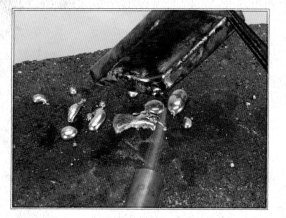

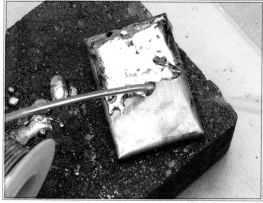

Coat inside with solder

Because this bezel will be filled with clear resin, coat the inside of the box with solder. To do this, pick the box up with pliers while it's hot and tip it around to let the solder flow around evenly. You will need to re-flux periodically. Be sure to only use the clear part of the flame and not the concentrated blue part. When you have coated all of the inside, turn the box over and, while applying an even heat, dump any excess solder out.

Coat outside with solder

Apply flux to the outside of the box.
Then, heat up the box and apply the solder.

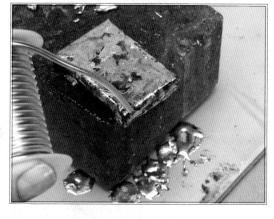

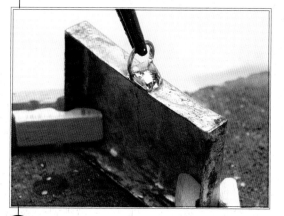

Solder sides

Then flux and solder the sides, letting the solder run down the sides and off the box.

Add top jump ring

Prop the box up on one long side using two clothespins. Apply a small glob of solder to one jump ring and, using the torch to heat up the top of the box, touch the jump ring (held with pliers) to the box to solder it on. You can also attach the jump ring using a soldering iron, if you prefer. (Note: The ring should be perpendicular to the side.)

Add bottom jump rings

Turn the box over, and in the same manner, solder one jump ring at each of the two corners.

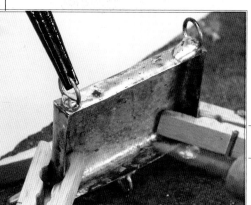

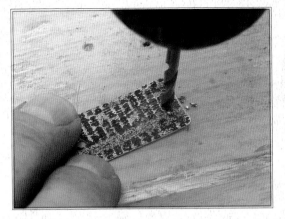

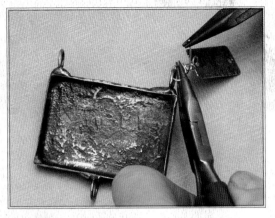

step 14 — Cut etched piece

Clean off the box with soap and water, then apply blackening solution to the entire box. Let it sit for a bit, then wipe off the excess. Polish the piece with a Dremel tool and a metal brush attachment. Cut a 1" × ⅜" (3cm × 10mm) piece of etched nickel sheet out, using metal shears. Hammer it smooth, then sand and file the edges. Use a center punch to mark for two holes—one on each short end—centered and about ³⁄₁₆" (5mm) from the edge. Drill at the two holes, making one hole ¹⁄₁₆" (2mm) and the other ⅛" (3mm).

step 15 — Connect etched piece

Turn the nickel piece over and hammer the back of the holes. Create a wire wrap in brass wire, connected to the smaller hole. Then wrap the other end to one of the jump rings in the corner of the box.

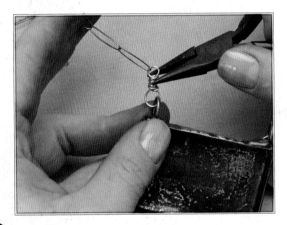

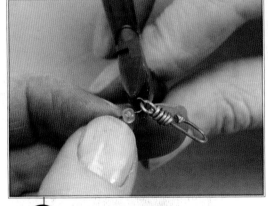

step 16 — Add chain

Cut another short length of brass wire and create another wire wrap for the jump ring in the other corner of the box. Attach one of the end links of vintage chain to the other end of the wrap.

step 17 — Connect chains

Continue adding random lengths of different necklace pieces until the finished piece is the length that you want. Create a hook out of sterling wire (see page 86) and blacken it. Add the hook to the end of the vintage necklace.

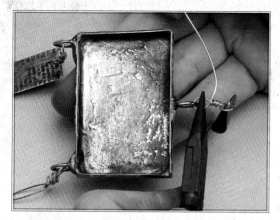

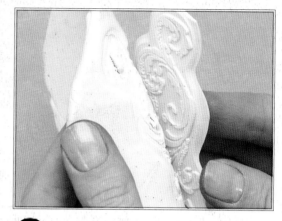

step 18 — Add bottom charm

Create a wire-wrapped loop for the leaf charms and add that to the jump ring at the bottom of the box.

step 19 — Release cast plaster

Brush blackening solution onto the brass wire and let it sit for minute, then wipe off the excess. Check to see if your plaster is set and peel the clay from the plaster.

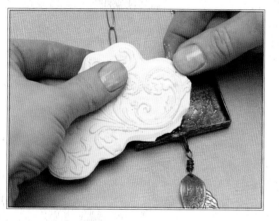

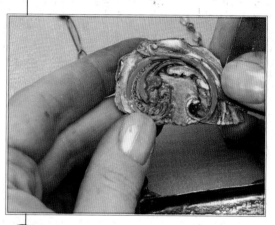

step 20 — Size cast plaster

Decide on a section of the plaster that you wish to use and carefully break it apart to the desired size.

step 21 — Paint plaster piece

Make the plaster appear old and weathered looking by adding washes of acrylic paint to it. Here, I am using burnt umber, robin's egg blue and moss green. When the paint is dry, sand it *lightly* with sandpaper to distress it. Then spray the plaster with spray sealer.

step 22 — Fill with resin

When the sealer is dry, apply a glob of gel medium to the back of the plaster and set it in the box. Let the gel medium dry for a few minutes. Mix up a small amount of two-part epoxy resin and pour it into the box very slowly to make sure it flows into all of the crevices. Fill it about one-third of the way, dislodge any bubbles with a lighter, then fill it up the rest of the way and dislodge the bubbles again. Set aside to cure.

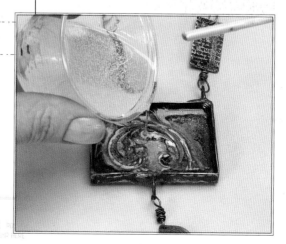

TIDE-SONG BELT

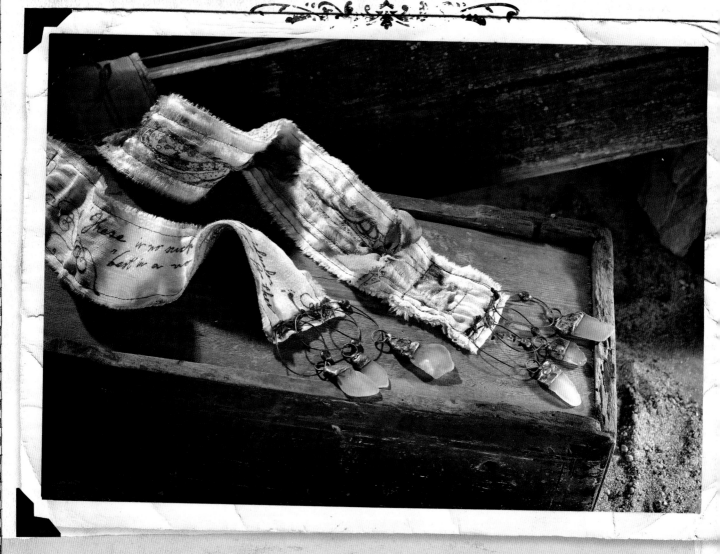

Day 324

TOMORROW—DEPARTURE DAY; OUR JOURNEY HOME BEGINS. Our goods are waiting on the backs of the mules and I'm almost overcome with sadness about leaving this place of beauty and the dear friends I have grown close to.

I walked down to the water to breathe in the evening air and clear my head for the long journey home. The waves rhythmically serenaded me into a state of relaxation and surrender. The setting sun warmed my face and a flood of memories filled my mind. I gathered a few shards of tumbled sea glass, palming their smoothness, then dropping them in my pocket. The water flowed in and back out again. It felt like the past and the future were converging at my feet at this moment with the short pause of the "breath" of the waves. The tide song sings with me of my gratitude for my time here and in my hope for a safe journey home.

Daypack Essentials

↓

REPURPOSING KIT

BLAZING PACK

silk strips

lace trim,
about 2" (5cm) wide

brass wire, 20-gauge

sea glass, 6 pcs.

silk embroidery floss

needle

fabric pen

step 1 — Sew silk and lace

Cut a piece of vintage lace trim to about 5'
(2m). Tear a strip of cream silk to the same width
and length as the lace trim. Sew the silk to the
lace trim. Sew a few random strips of other
fabrics to the top of the silk. Here, part of the
scraps I used included a beaded shirt, and the
beads add a nice texture. Leave some of the silk
areas plain and use a fabric pen to doodle in
those areas.

step 2 — Create sea glass caps

Turn the ends of the belt under and sew them
to create a finished edge. To create sea glass
charms, begin by wrapping the ends of the
pieces in copper tape. Burnish the tape to the
glass really well.

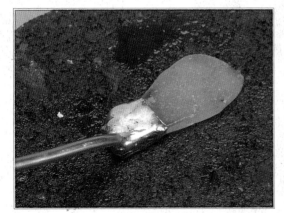

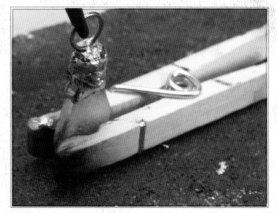

step ❸ ## Add solder to glass

step ❹ ## Add jump ring

Brush flux onto the copper and also onto a jump ring. Using a small torch flame, add a bit of solder to the tape and let it flow around to cover the tape.

Prop the piece up with a clothespin and, using the torch, pick up a bit of solder on the jump ring and then solder it to the charm.

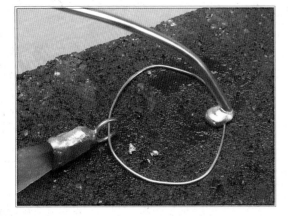

step ❺ ## Add brass rings

step ❻ ## Sew rings to tie

Hold the charm by the jump ring and heat the piece with the torch to let the solder bulk up just a bit around the base where it meets the glass. When cool, test the charm to see if the tape will sufficiently hold the solder on. If not, glue the solder cap on with caulk. Repeat for the other five charms. Create six large, oval brass wire ring/links, about 1" × 1½" (3cm × 4cm). Hammer them a bit and then thread each one with one of the sea glass charms. Solder the ring closed.

Wash and dry all the link-sea glass charms to remove any flux or solder residue. Blacken with blackening solution, wipe off excess and polish to desired sheen with Dremel and wire brush. Stitch three oval rings to each end of the belt, using a needle and embroidery thread. Your belt is now ready to wear.

RESOURCES

THUNBERBIRD SUPPLY COMPANY
www.thunderbirdsupply.com
sheet metals, metalsmithing tools

FIRE MOUNTAIN GEMS AND BEADS
www.firemountaingems.com
beads, sterling silver supplies

RIO GRANDE
www.riogrande.com
sterling silver supplies, metalsmithing tools

OF THE EARTH
www.custompaper.com
beautiful hand-dyed silk ribbon

ACE HARDWARE *(I'm partial to my local store)*
www.acehardware.com
plaster, glues, torches, soldering supplies, tools and more!

CANFIELD TECHNOLOGIES
www.canfieldmetals.com
solder

ETSY
www.etsy.com
findings, inspiration, supplies

GOODWILL AND OTHER THRIFT STORES
www.goodwill.org
findings, vintage jewelry and more!

YARD SALES — *the more the merrier!*

A modern day expeditioner,
I like to look under what I might
otherwise walk right past.

INDEX

ABOUT STEPHANIE

THE CONTOURS OF MY HEART trace back through history even though my feet have never walked the roads of time beyond the short segment I inhabit. A modern day expeditioner, I practice my own version of archeology, scanning the terrain for intriguing bits and pieces that present themselves (or that are hiding but don't easily escape my grasp). My love of music, words and creative expression (not exclusive to making art) is the morning songbird at my window saying, "Wake up and get moving! The world won't wait for you to decide you are brilliant. Get up and work anyway!"

I travel with dear companions who tolerate and encourage my skewed perception of beauty in a world where originality is subjective. I venture out daily with my cockeyed optimism in tow and no particular destination in mind. The only objective being to meet myself somewhere along the path, to grab a friend or two to travel alongside me, to look under what I might otherwise walk right past, to bite into a tomato and feast, letting the juices run down my arms. And always—always, always, always, I must indulge in a good laugh whenever possible.

Pretty Little Things
Sally Jean Alexander

Learn how to use vintage ephemera, found objects, old photographs and scavenged text to make playful pretty little things, including charms, vials, miniature shrines, reliquary boxes and much more. Sally Jean's easy and accessible soldering techniques for capturing collages within glass make for whimsical projects, and her all-around magical style make this charming book a crafter's fairytale.

ISBN-10: 1-58180-842-9
ISBN-13: 978-1-58180-842-1
paperback 128 pages Z0012

Altered Curiosities
Jane Ann Wynn

Discover a curious world of assemblage with projects that have a story to tell! As author Jane Ann Wynn shares her unique approach to mixed-media art, you'll learn to alter, age and transform odd objects into novel new works of your own creation. Step-by-step instructions guide you in making delightfully different projects that go way beyond art for the wall—including jewelry, hair accessories, a keepsake box, a bird feeder and more—all accompanied by a story about the inspiration behind the project. Let *Altered Curiosities* inspire you to create a new world that's all your own.

ISBN-10: 1-58180-972-7
ISBN-13: 978-1-58180-972-5
paperback 128 pages Z0758

Secrets of Rusty Things
Michael deMeng

Learn how to transform common, discarded materials into shrine-like assemblages infused with personal meaning and inspired by ancient myths and metaphors. As you follow along with author Michael deMeng, you'll see the magic in objects such as rusty doorpulls, quirky odds and ends. This book ge techniques, shows you where provides a jump start for you to ces.

tape and a cut-and-fold shri
for getting your creative jui
cases eye candy artwork and
from some of the hottest co
artists on the Zine scene too

ISBN-10: 1-58180-879-8
ISBN-13: 978-1-58180-879-7
paperback 144 pages Z0346